Who We Were

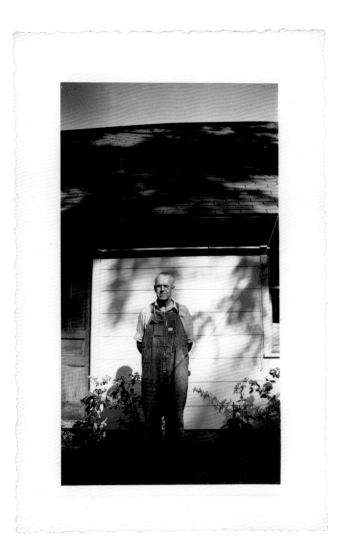

Written on the back: "Sunday afternoon, everything's normal."

Who We Were

A SNAPSHOT HISTORY OF AMERICA

MICHAEL WILLIAMS

RICHARD CAHAN

NICHOLAS OSBORN

CHICAGO
CITYFILES PRESS
PUBLISHERS

© 2008 by CityFiles Press

Published by CityFiles Press, Chicago
E-mail: cityfilespress@rcn.com
Website: cityfilespress.com

Produced and designed by Michael Williams

ISBN: 0-9785450-1-x
ISBN-13: 978-0-9785450-1-7

First Edition

Printed in Canada

Table of Contents

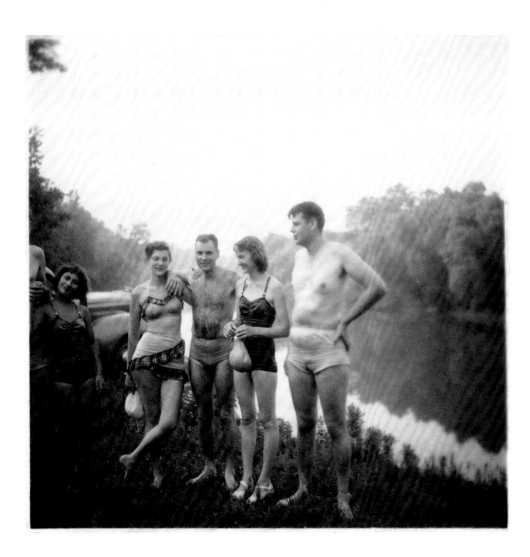

FOUR FAMILY MEMBERS GATHER AT "THE BLUFF" OVERLOOKING THE OUACHITA RIVER IN ARKADELPHIA, ARKANSAS, IN 1951. THEY ARE (FROM LEFT): DELLA SUE SIMONSON, EUGENE SIMONSON, SISTER-IN-LAW RUTH SIMONSON, AND EVERLY SIMONSON. DELLA BECAME A PEDIATRICIAN; EUGENE SERVED AS AN ARMY COLONEL, AND RUTH WORKED AS A NURSE. HER HUSBAND, EVERLY, A MEDICAL STUDENT, WAS KILLED THE NEXT YEAR IN A PLANE ACCIDENT. THIS PHOTOGRAPH WAS FOUND DECADES LATER AT A NEW YORK STATE FLEA MARKET, AND EVENTUALLY LINKED TO EUGENE, WHO VIVIDLY RECALLED THE DAY.

All Our Yesterdays

Every photograph in this book was taken for a personal reason. Each photo is a simple, small document composed to save a moment or a memory. Barns and beaches, buggy rides and baptisms. "Snapshots are taken out of love, and to remember people, places, and shared times," writes photographer Nan Goldin. "They're about creating a history by recording a history."

The more than 350 snapshots from all over America collected here sketch a personal history of the nation from 1888, when the first snapshot was taken, until 1972, more than a quarter century ago. This is a story pieced together from pictures found in shoeboxes and at flea markets. Of an authentic America with no pretense. It's a bit of an off-beat history—framed in deckled edges. The street-level perspective might be jarring at first, but the view will grow familiar because this is a story that we created ourselves. A people's photo history, all recorded by amateurs.

The photographs form a crazy quilt of steamships and biplanes, migrants and flappers, seal clubbers and suffragettes. From the sod homes of South Dakota to the skyscrapers of New York City. The Wright Brothers, the world wars, and Woodstock. This is who we were.

* * * * * *

You can argue that the first photograph ever taken was a snapshot. Joseph Nicéphore Niépce, after all, was not a professional photographer, but an inventor. And his first photo, the view from an upper-floor window looking toward the barn and courtyard of his French estate in 1826, was certainly a personal record. But the image, which took at least eight hours to expose, was anything but rapid. And the term snapshot, which derives from a hunter's quick, cocked, rifle shot, implies speed and spontaneity.

Because early photographers needed time and deliberation to catch a fleeting figure, we advance the

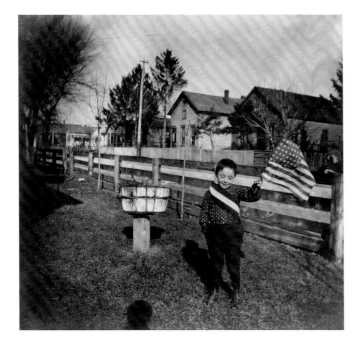

RESIDENTS LINE THE STREETS OF MUNCIE, INDIANA, TO GREET THEODORE ROOSEVELT AS HE CAMPAIGNS FOR PRESIDENT ON OCTOBER 11, 1900. "EVERYWHERE THE WORKINGMEN SEEMED TO DESIRE THAT GOVERNOR ROOSEVELT SHOULD SEE THEM AT THEIR BEST, SO THEY APPEARED IN HOLIDAY ATTIRE," THE *NEW YORK TIMES* REPORTED. "WE GOT A SALUTE FROM 'TEDDY,'" READS A NOTE ON THE BACK OF THE PHOTO.

Eastman next introduced an easy-to-use camera. He built a square, leather-covered wooden box and called it the Kodak. The Original Kodak, first available in 1888, and the Kodak No. 1 and No. 2, which soon followed, made photography doable for most Americans. At $25 the camera was not cheap, but it was remarkably convenient. With a fixed-focus lens, which meant no focusing was required, the first Kodaks took pictures at the single speed of 1/25 of a second and came packed with photo material to make 100 photos—more pictures than most amateurs had ever seen. After completing a roll, America's new photographers sent the camera back to Eastman's factory. Ten days later, mounted prints and a freshly loaded camera returned. The snapshot was born.

Just about every history of American photography mentions George Eastman and the development of his early cameras. But few histories go beyond that. Few discuss the billions of snapshots that have been taken since the Original Kodak was introduced. Instead, they focus on America's great photographers—Alfred Stieglitz at the turn of the century and his colleagues like Edward Steichen, the documentarians of the thirties such as Dorothea Lange and Walker Evans, and *Life* photojournalists such as Margaret Bourke-White and Gordon Parks.

Stieglitz, Steichen, and the major photographers who followed told big stories with big cameras. They dealt with big issues and took photographs backed by big ideas. They left the small stories to the rest of us. It is the snapshooters who create pictures we pass down. And it is the snapshooters who help us understand who we were and who we are.

* * * * * *

Photography has been labeled a craze since the start. The moment in 1839 that Niépce's one-time partner, Louis-Jacques-Mandé Daguerre, announced that his daguerreotype process of fixing an image was a "free gift to the world," Daguerre's disciples headed out to all corners to bring back views of distant lands. "Daguerreomania" had struck. In 1883, five years before the Kodak was introduced, the **New York Times** reported a particularly virulent form. "Last summer it was a common sight to see nicely dressed young fellows loaded down with cameras and tripods at the trains and steamboats," the newspaper reported. "There is hardly a bit of romantic landscape, river or mountainside, that has not been photographed." Six years later, the *Times*

calendar at least sixty years before we find the first real examples of photo snapshooters. Until the 1880s, picture takers were part chemist, part magician, and part artist. They needed to know how to mix and apply a smelly collodion chemical upon a glass plate before capturing an image, and then had to coax that image to life in a dark tent before the plate dried.

All that changed when amateur photographer George Eastman quit his bank job in Rochester, New York, determined to figure out a way to simplify the complex process of making a picture. His first step was to set up a small factory that manufactured dry plates, actually called gelatino-bromides, which did away with the gooey, wet plates and the need for a portable darkroom. Then he produced what he called "American film," a roll of flexible, transparent, light-sensitive paper that replaced wet and dry plates altogether.

THE END OF WORLD WAR I, KNOWN AS THE GREAT WAR, IS CELEBRATED IN GULFPORT, MISSISSIPPI, ON NOVEMBER 11, 1918. AN ARMISTICE BETWEEN THE ALLIES AND GERMANY WAS SIGNED ON THE "ELEVENTH HOUR OF THE ELEVENTH DAY OF THE ELEVENTH MONTH." PEACE WAS COMMEMORATED IN THOUSANDS OF TOWNS BY PARADES, SEARCHLIGHTS, SIRENS, AND BELLS.

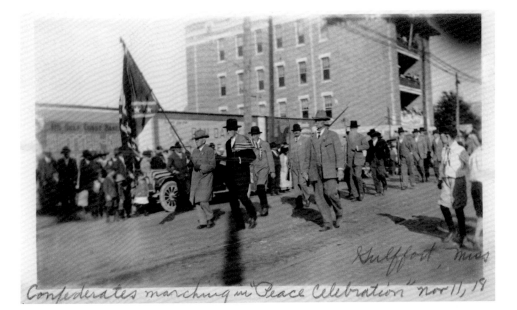

Confederates marching in "Peace Celebration" Nov 11, 18 *Gulfport, Miss*

noted that amateur photographers were scattered across the country. "The woods of the Catskills, Adirondacks, White Mountains, and Blue Ridge are full of them," the paper reported. By 1890, twenty hotels, including the new Hotel del Coronado in San Diego, offered darkrooms for determined amateurs.

The last decade of the nineteenth century was a wondrous time for amateur photographers, who could choose between the Kodak and dozens of other cameras like the Pocket Kozy, Bo-Peep, Pocus, Hawk-eye, Wizzard, and Premo. While many of the early snapshooters sent their negatives back to Kodak for printing, serious amateurs insisted on developing their own—not an easy process. They needed film or plates and plate holders, developer and hypo, wash boxes, dry racks, sensitized paper, card mounts, albums, frames, backgrounds, camel hair dusters, and a ruby lamp for their darkroom. If they took pictures inside, they needed flash-sheets—dangerous, flammable paper that would provide a burst of light for what was called flashlight photography. Photographers were easy to identify during those days because most sported hand wounds from using the flash-sheets. "It is difficult to find an amateur of any experience who has not tried his luck with a flash light," wrote the *Times*, "and the tied-up digits simply represent too close dallying with powdered magnesium."

George Eastman's ingenuity paved the way for many of the early camera crazes. In 1900, he introduced the $1 Brownie camera. About 150,000 Brownies were sold during the camera's first year, three times the number Eastman had sold in any previous year. And in 1914, Eastman introduced Autographic Kodaks, cameras that made it possible for amateurs to write information—such as names or dates—directly on their film by use of a metal stylus. This made the camera "doubly valuable" by including "authentic history," the company advertised.

In the late 1920s, the first 35mm camera, a Leica from Germany, was introduced in America. Known originally as a "candid camera" or "miniature," the small camera sparked a new interest in photography. "Candid cameras were everywhere," wrote Frederick Lewis Allen in *Since Yesterday,* his history of the thirties. Reported *Literary Digest* in 1937: "Judging from the astonishing growth of camera-supply stores, photographic schools, prize contests, and magazines for amateur photographers, what was once a Sunday afternoon pastime is now a national mania."

That mania stalled briefly during World War II, but reemerged soon after the war when color print film and picture-in-a-minute Polaroid cameras were introduced. By the mid-1950s, most U.S. families owned a camera. That number increased during the 1960s with the introduction of Kodak Instamatic, and increased again forty years later with the advent of digital cameras. For most of us growing up in

AMATEUR PHOTOGRAPHERS WERE ENCOURAGED TO MAKE THEIR OWN SILHOUETTE PORTRAITS. "THEY'RE THE KIND, TOO, THAT HELP LEND VARIETY TO YOUR ALBUM," ONE AD SUGGESTED. THESE IMAGES WERE MADE BY SHINING SEVERAL BACKLIGHTS ON A BEDSHEET.

the twentieth century, our first taste of photography was the family snapshot. We unknowingly posed in our mother's arms, smiled with our brothers and sisters on the porch, and blew out our birthday candles in front of a camera. Our photos were kept in family albums, which filled us with delight and laughter. But before long, we were cued to the fact that few people outside our circle wanted to look at these photos. The family slide show? What a bore.

So families generally kept their own histories. Stories that remained disjointed and private. Until now.

* * * * * *

Photo amateurs, the makers of snapshots, have had a checkered reputation ever since they started taking pictures. "It is well known that amateurs have produced the best and most interesting pictures," wrote the *Chicago Tribune* in 1887. "They are found at both extremes; it must be confessed that the worst results are found in their hands. Professionals are conservative. They make no new moves. They take no risks involving expenditure of money on failures. They follow established rules, and make no mistakes. At the same time they accomplish no brilliant successes."

Since the start of the snapshot years, photo experts—i.e. camera store clerks, photofinishers, professionals, and avid amateurs—have tried to drum in the dos and don'ts of shooting. Do place your subject in the middle of the frame; don't shoot into the sun. Do use an exposure meter; don't shake the camera. Americans, by and large, have ignored these rules—and thank goodness for that. They take pictures the way they want. No matter how many times they are told otherwise, they use a flash at night to photograph the Lincoln Memorial from blocks away, or trip the shutter before they are firmly set. The result: An inconsistent but wonderfully quirky look at America.

In spite (or perhaps because) of the omnipresence of the snapshot, amateur photography has been largely disregarded in the arena of high art until the past few years. In 1943, New York's Museum of Modern Art held a two-month show with hundreds of snapshots culled from the files of the Eastman Kodak Company. Williard D. Morgan, director of the museum's photography division, called snapshots "the medium of the millions" and declared snapshots important folk art. But by the 1950s, the term snapshot was a dirty word in photo circles.

"Today even the most amateur photographer reels under a pride-crushing blow if his pictures are referred to as snapshots or having a 'snapshot-ish' quality," wrote Dorothy Fields in a 1956 issue of *Popular Photography*. "Nowadays, photographs must have a Message, artistic appeal, stark realism, feeling of movement, unique cropping or an overabundance of flesh spilling out of a bikini to qualify as worthy of a niche in this higher echelon of The New Art."

Fields longed for the day when people simply took photographs just to make a record. Cameras, she wrote, had become too complicated with light meters, filters, and a choice of f-stops.

"In our mothers' day a gathering of the clan, the first day of school, or just a Sunday picnic was the occasion for mom to bring out the trusty folding Kodak or box Brownie, wipe the dust off the lens with a corner of her handkerchief (no fancy lens brush), check the little red film window (what happened to these?), back up the required

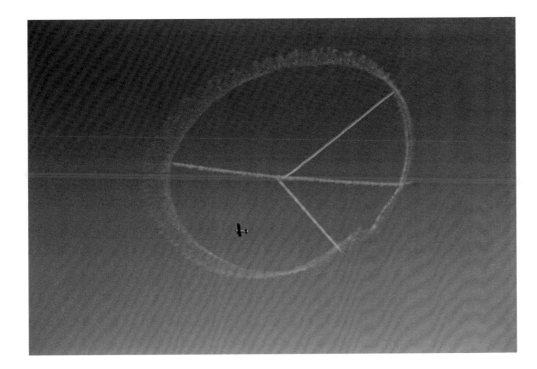

THE SKY ABOVE A VIETNAM PROTEST IN BOSTON COMMON ON OCTOBER 15, 1969. MANY OF THE 100,000 PEOPLE AT THE MORATORIUM TO END THE WAR IN VIETNAM CHEERED WHEN THE PILOT COMPLETED THE PEACE SYMBOL.

ten or twelve feet (no range-finder problems), glance behind her to make sure the sun was over her shoulder, click the shutter, and record the scene for posterity," Fields wrote.

That's what Eastman had in mind when he wrote that his new invention would serve as a time capsule. "Photography is thus brought within the reach of every human being who desires to preserve a record of what he sees," he wrote. "Such a photographic notebook is an enduring record of many things seen only once in a lifetime and enables the fortunate possessor to go back by the light of his own fireside to scenes which would otherwise fade from memory and be lost."

Eastman saw the snapshot as a personal record. What he failed to see was the possibility that a huge collection of diverse snapshots could tell history. Even though almost all snapshots are taken for personal reasons, they contain data and evidence that tell about communities, towns, nations, even eras. Just about every photograph in this book was once a part of a family's possessions, taken by parents, uncles, and aunts. That does not make them truer or purer than commercial or artistic photographs, nor does it make snapshots more or less beautiful. What they do share, however, is an

unpretentious spirit and an insider's view. They are ground-level pictures produced by anonymous people out to create a visual diary of their own lives. When put together, snapshots provide a photographic record of us all. Like folk songs, they are the annals of everyday life.

The digital snapshots of today are quite different from the film snapshots in this book. With cell phone cameras, digital point-and-shoot and single-lens reflex cameras, we fire at will, amassing hundreds of images of even a single event. Many of these images—what we consider our mistakes—are tossed away to the chagrin (and relief) of future historians. The photographic record that we now create is both remarkable and overwhelming. It tells of a new time in a new way.

The photographs in this book, of course, don't tell the whole story. This is just one rambling walk through the briar patch of what we call America. It is a celebration—not a blind celebration—of an America that can never be resurrected or recreated. It tells of decades when farmers had all winter to while away their time. It tells of a place where people sat on front porches, or prayed in their backyards. It's an America of loners and eccentrics, soldiers and hippies, Okies and cotton pickers. Not a better America. Not a worse America. But our America.

This Is Your Book

To gather 350 snapshots during the past ten years, we have looked at more than a million images. We never tired of viewing them. Just about every snapshot lets us peek into other people's lives. Just about every one tells a backyard history.

We love snapshots, and we love the recent books that celebrate the aesthetic beauty of snapshots. When presented properly, snapshots take on an undeniable artistic quality. But the value of snapshots goes far beyond that. This book celebrates the snapshot as a document. It attempts to provide the historic context of each snapshot in order to tell America's story. The photographs in this book are not ordinary snapshots. They were chosen because of their unique ability to help tell the American story.

It was easy to determine the starting point of the book because the first snapshots were taken in 1888. But when to end? At first we considered the year 2000, when digital photography came to the forefront. But we found it difficult to place the past three decades in the proper perspective. The last photograph in the book, by astronaut Charles Duke, sums up America's love of the snapshot—so we end there, in 1972, on the lunar surface.

This book would not have been possible a decade ago. Although the photographs were all made by then, access to millions of snapshots was impossible. We were helped by the Internet, which let us look at hundreds of thousands of photos, and put at our disposal a remarkable trove of information. The Internet was essential in tracking down captions. The photograph on Page 50 of a cemetery, for example, had no accompanying information when we found it. By typing in the names on the visible tombstones, we traced the photo to a cemetery in Milwaukee, Wisconsin. When we typed in the name of Gustav Mech, we found him mentioned in the online 1902 diary of Milwaukee Police Officer William Bramwell Sizer.

To understand these photographs, we also relied on libraries. In particular, we used the Skokie (Illinois) Public Library, Evanston (Illinois) Library, and Northwestern University Library, and snuck into the International Center of Photography Library in New York City. The amount of fines we have paid during the past years is a testament to how many books we perused.

From the start, this book took on a life of its own, directed by the photographs we found. Like novelists, we watched where our characters led us. Sometimes the photographs confirmed the American saga; sometimes they ran counter. To fill missing gaps, we relied on Flickr.com, an online photo sharing website with more than 3 billion images. The majority of Flickr photos are contemporary—last night's party or baby's first steps. But millions are old family snapshots. We looked at thousands of Flickr photos, and found about fifty that were candidates for the book. Once we identified them, we contacted Flickr members for permission to use their snapshots. Almost every person agreed.

Thanks go to Flickr members Keith Ward, Thomas Stevick, Stanley Fader, Charles Rathbone, James and Linda Breslin, K.C. Winstead, and others, who all went to extremes to help us—complete strangers. Many sent family heirlooms. Wrote Winstead: "Okay, I want one dollar, cash, and a copy of the book for the use of the photograph. I'd ask for some real money, like five dollars, but I like what you have done so far, so I am cutting you a deal." Perhaps the spirit of the project was best personified by Louise Parsons, who outbid us on eBay.com (not difficult), but was willing to share her newly purchased photo of sharecroppers.

Many people scanned and sent snapshots that did not make the book, but are worthy of publication. Of particular note are Victorie Floors of the Netherlands, who sent a family photo from a 1915-era Atlantic Ocean liner crossing; John B. Williamson of Scotland, who sent photos from a 1967 family vacation to the United States, and Floyd Norman, who sent 1920s flapper photos. Other Flickr members supplying fine photographs that got lost on the cutting-room floor were Leon Reed, John Van Noate, Rose Vikony, John Christensen, Nicole Espinola, Lauree McArdle, Rick Abbott, Mike Brown, Barbara Lawrence, Tom McKinnon, Gay Howard, Delina Porter (who goes by "PixelPackingMama" on Flickr), Kris Calhoun ("KlickerChick"), and many others.

Helping us identify pictures were Jack L. Whitacker, our expert on cars; Steve Doancik, our airplanes expert; Divide County (North Dakota) Journal publisher John M. Andrist; Rick Zitarosa, of the Navy Lakehurst Historical Society; Martin Tuohy, of the National Archives and Records

Administration; Greg Borzo, of the Field Museum of Natural History; tree expert Scott Wade; Mike Stowe; James K. Gomez; John Jaros; Mary Ann Pirone; Charles M. Mobley; Merritt Brown, and Gene Simonson. Thanks to Paul Jackson, of the United Kingdom, who knows where the best Flickr photos reside, and to Philip Liebson, who has a savant-like ability to date photographs.

Every picture tells a story. But many remain mysterious. We view this book as a dialogue between the authors and readers. Some of the photographs in this book need additional identification. Despite our best effort, we could not figure out the town that hosted the African American baseball team on Page 100 or where the Ku Klux Klan paraded on Page 101. We have attempted to show every picture in this book in a respectful manner, and we hope that readers can provide insight and information about each picture, which will be incorporated in future editions.

Thanks go to collectors Robert Jackson, Anthony Vizzari, Joel Rotenberg, Ron Slattery, and Mark Jackson, who share our passion for snapshots; Michael Flug, of the Harsh Research Collection of Afro-American History & Literature, and Rita Arias Jirasek, who gathers photographs of Mexican Americans. Helping us frame the entire book were photo historian Joel Snyder and scholars Kenan Heise and Paul Fischer. The support of Thomas Osborn made this project possible.

We would also like to thank dealers Steve Bannos, Larry Baumhor, Estelle Rosen, Don Colclough, Bob Hooper, James Haack, Stacy Waldman, Cheryl Ohland, and Ray and Kathy Hetrick, who sparked our interest in snapshot photography and patiently let us spend hours in their stalls while higher-paying customers jostled with us for space. Collectors rely on dealers to keep an eye out for good material, and Dean and Carol Kamin, Wayne Bauer, and Ron Anderson have held special snapshots to give us a first look. The knowledge and enthusiasm of these dealers were indispensable.

Special mention has to be given to Joyce Morishita and Bert Phillips, who allowed us access to their collection of photographs without limit. Keith Sadler's generosity helped make this book what it is. He also helped make the long drives to rural markets entertaining and thought-provoking.

And the CityFiles Press crew of Mark Jacob, Caleb Burroughs, Cate Cahan, Claire Cahan, and Karen Burke, who edit, reshape, and refine our books. They make us and our work look good.

America is often pictured as a progressive nation at the forefront of just about everything. But what this book shows is that we are also a nation determined to hold onto our past. Life is fleeting, and we work hard to remember. Taking photographs helps. This collection shows a nation that is stubborn and bold—and sentimental. This is a unique book in that it belongs to us all. It was made by hundreds of photographers who worked for more than a century. This is your book.

A GUIDE TO THE PHOTOGRAPHS

Some of the photographs used in this book were identified by date and location on the front or back of the photo, or in a photo album. Most, unfortunately, were not. We have attempted to identify each photograph based on the photo paper, style, technique, and the content. We did not use an exact chronology in the text because many of the photographs are undated. But we present the photographs in approximate chronology in order to show the nation as it grows and transforms.

We have included most of the words that were written on the backs of these photos. These words appear in italics directly beneath the date or location of each photograph. Many of the words that we found written on old photographs are both lyrical and wonderfully mysterious.

Each photo caption begins with a short title in bold face. These titles are based on actual phrases we found in photo albums. After compiling a list of hundreds of these phrases, we attached them to the snapshots in this book. Titling album photos is an art onto itself. Titles are often funny and clichéd, sometimes provocative and sometimes innocent. We've tried to keep that spirit.

Almost all photos in this book are reproduced at actual size. Readers will see exactly what we saw when we discovered each photograph. Size is part of the magic of snapshots.

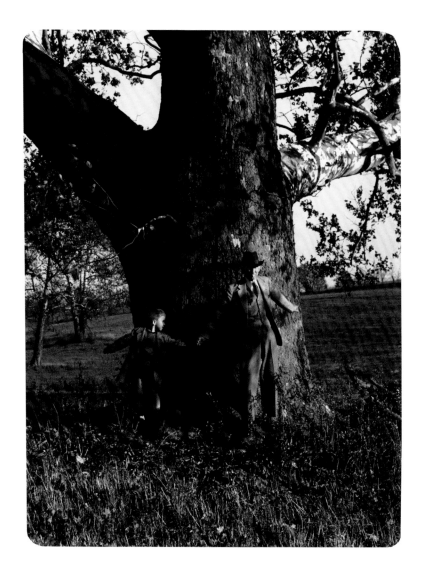

ONE OF PENNSYLVANIA'S LARGEST AND OLDEST TREES, THE JOHN GOODWAY
SYCAMORE IN LINGLESTOWN, IS MEASURED BY HARVEY WARD AND HIS
GRANDSON, LESTER AUNGST, IN THE LATE 1940S. THE TREE, ABOUT 300
YEARS OLD, STILL EXISTS.

"I am a passionate lover of the snapshot, because of all photographic images it comes closest to the truth. The snapshot is a specific spiritual moment. It cannot be willed or desired to be achieved. It simply happens to certain people and not to others. Some people may never take a snapshot in their lives, though they take many pictures."

—Photographer Lisette Model

'A Romance'

A little black box, no larger than a cigar case, changed the way we pass memories down from generation to generation.

With the introduction of the easy-to-use Original Kodak in 1888, ordinary Americans could capture everyday life. Until then, photography was the domain of the professional or serious amateur. But now, no need for a tripod or focusing cloth to shield the sun. No more ruby lamps or smelly darkroom chemicals. "You press the button, we do the rest," promised George Eastman. For the first time, photography belonged to the people.

The new "instantaneous" camera and the dozens that soon followed were an immediate success. Snapshooters photographed their homes and hometowns, children and pets, birthdays and christenings. They photographed their journeys, packing box cameras on vacations or jaunts through the woods. And Americans used cameras to tell stories. Their early experiments were playful and full of daring as they froze time to mark relationships, romance, and even death. The images they made were annotated, bound, and carefully secured in a special place—the cherished photo album.

Because the first cameras cost $25, most early photographers were middle-class or wealthy. But just a month into the new century, the $1 Brownie camera was introduced. Now, everyone could record what they saw. A record that could last forever.

ABOUT 1900

SEEING STARS: AN AMATEUR PHOTOGRAPHER CREATES A UNIVERSE. A FEW OF THE EARLIEST PHOTOGRAPHIC PRINTS WERE ACTUALLY PHOTOGRAMS, PICTURES THAT RECORDED SHAPES WITHOUT THE USE OF A CAMERA. THEY WERE MADE BY PLACING OBJECTS—COINS, KEYS, OR LEAVES—DIRECTLY ON PHOTOSENSITIVE PAPER, AND EXPOSING THE PAPER TO LIGHT. THE RESULTS WERE CHARMING SAME-SIZE SILHOUETTES.

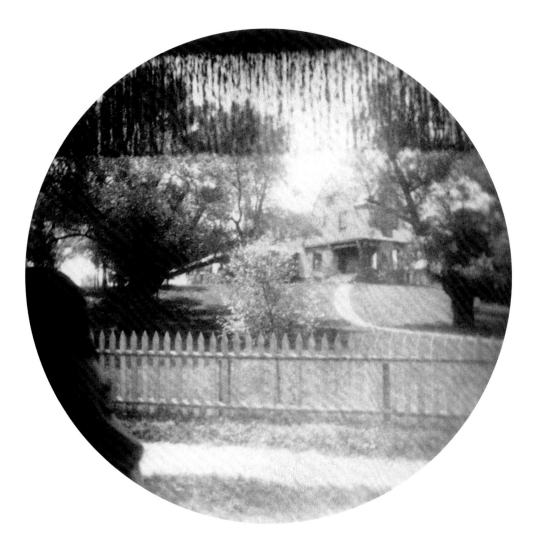

ABOUT 1890
COUNTRY FROLIC: THE VIEW FROM A SURREY WITH THE FRINGE ON TOP, TAKEN BY ONE OF THE MOST POPULAR EARLY SNAPSHOT CAMERAS, THE KODAK NO. 1. IT PRODUCED CIRCULAR IMAGES THAT WERE 2 1/2 INCHES IN DIAMETER. "ANY BOY CAN USE IT," INVENTOR GEORGE EASTMAN DECLARED. "NO KNOWLEDGE OF PHOTOGRAPHY IS REQUIRED."

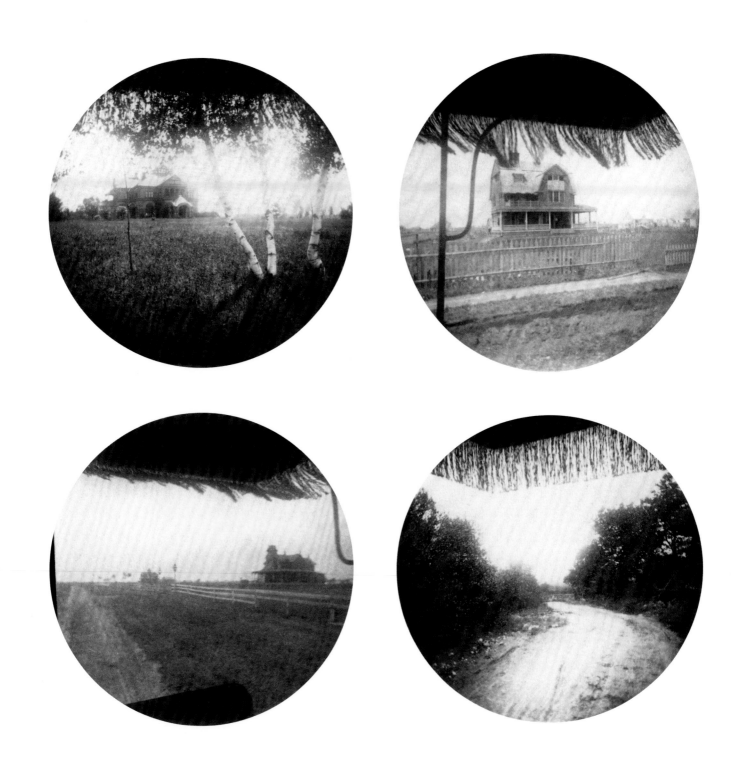

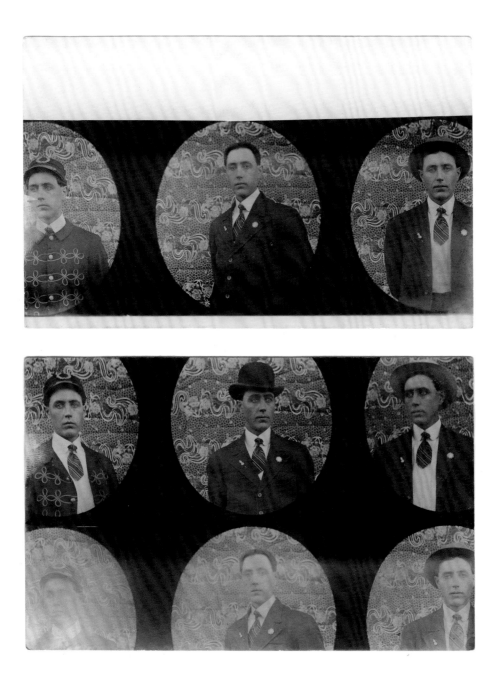

ABOUT 1906

SEEING CIRCLES: A GENTLEMAN MODELS THE FASHIONS OF THE DAY IN THIS COMPOSITE PHOTO, AN EARLY RAGE. THE IMAGES ARE PRINTED ON POSTCARD-SIZE PHOTOGRAPHIC PAPER, WHICH WAS RIGID ENOUGH TO BE SENT THROUGH THE MAIL.

1910—EUCLID, MINNESOTA
Wish you all what is grand, good and noble for the New Year.

[ABOVE AND FOLLOWING PAGES] **HIGHFALUTIN':** FANCY BORDERS ENLIVENED EARLY TWENTIETH-CENTURY SNAPSHOTS. AMATEURS AND EARLY PHOTOFINISHERS LAID STENCILS AND MATTES OVER PRINTS TO GIVE HOMEMADE PHOTOGRAPHS A MORE POLISHED LOOK.

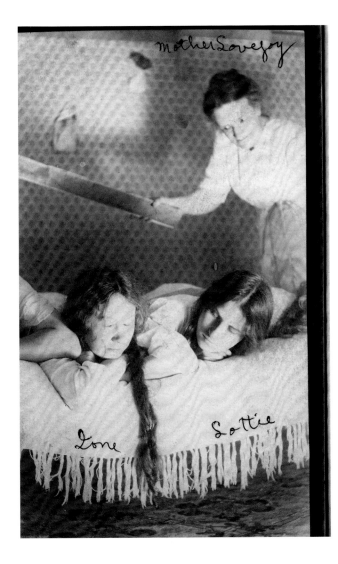

ABOUT 1900
HANKERING FOR A PADDLE: EARLY PHOTOGRAPHERS OFTEN STAGED SCENES TO TELL STORIES. SOMETIMES THEY USED A SINGLE SHOT; SOMETIMES THEY EMPLOYED MULTIPLE IMAGES.

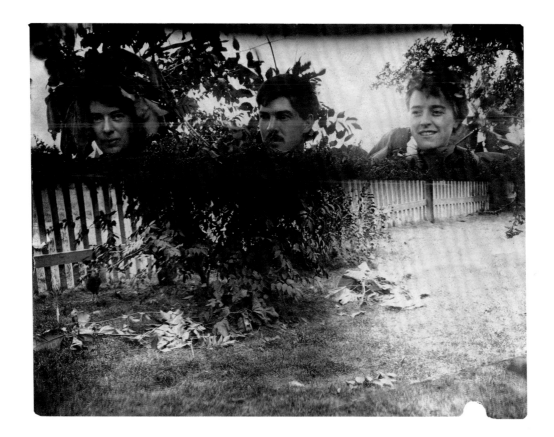

ABOUT 1900
NOSEY NEIGHBORS: DOUBLE EXPOSURES, BOTH INTENTIONAL AND ACCIDENTAL, CREATE STRANGE AND OFTEN HUMOROUS JUXTAPOSITIONS. THIS ONE AND MANY FROM THE PERIOD WERE CAREFULLY PLANNED. ACCIDENTAL DOUBLE EXPOSURES WERE COMMON UNTIL THE 1970S, WHEN AUTOMATIC FILM ADVANCE IN CAMERAS BECAME AVAILABLE.

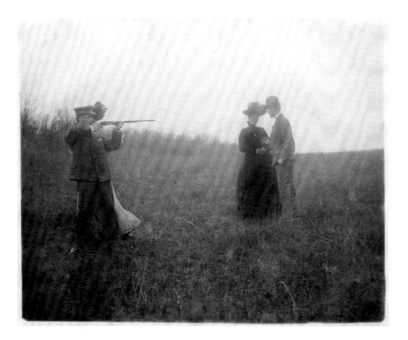

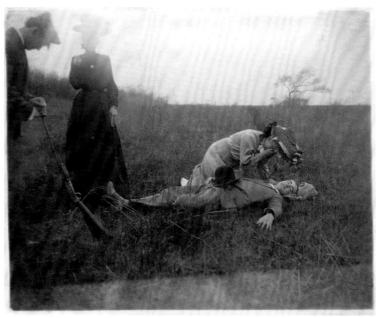

1905—MASON CITY, IOWA
A romance.

STRAIGHT FROM A DIME NOVEL: A STAGED LOVE TRIANGLE PLAYS OUT IN A FIELD NEAR WILLOW CREEK. THE PICTURES COMPRISED A PAGE IN A PHOTO ALBUM.

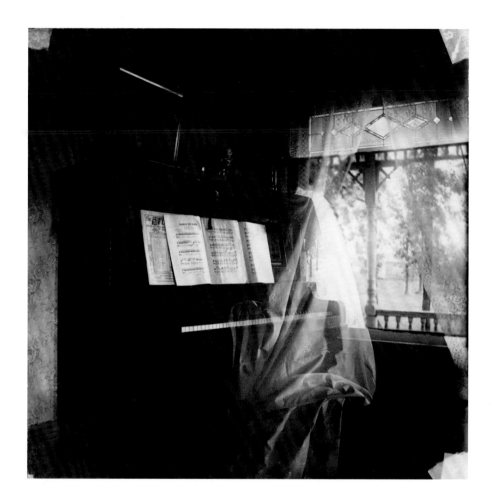

ABOUT 1905
PURE HOKUM: "SPIRIT PHOTOS," CREATED THROUGH CLEVER DOUBLE EXPOSURES, FOOLED GENERATIONS OF VIEWERS, SOME WHO PAID GOOD MONEY FOR PROOF THAT THEIR DECEASED LOVED ONES WERE STILL AROUND. "OF ALL THE IMPOSTURES EVER PALMED OFF UPON A CREDULOUS WORLD, SPIRIT PHOTOGRAPHY IS THE MOST SHAMEFUL AND THE MOST SHAMELESS," WROTE THOMAS BEDDING, IN *PHILADELPHIA'S PHOTOGRAPHIC PROGRESS*. HE CALLED SPIRIT PHOTOGRAPHY A "LIE AND A FRAUD."

'Ain't It A Dandy'

The larger-than-life early photographers of the West—Timothy H. O'Sullivan, William Henry Jackson, Carleton E. Watkins—sent back breathtaking images from their surveys of grand mountains, deep gorges, and luxuriant valleys. Their pictures, tipped in early photo books or sold as three-dimensional stereoviews, stirred the imagination of Easterners and new immigrants, who set out for the frontier in search of freedom and land. Americans have always been hooked on horizons.

The lure of the West carried forward into the early years of the twentieth century. When the last Native American land was opened to settlement in 1909, more than 80,000 pioneers registered for 10,000 land claims in South Dakota. Along with their dreams, the homesteaders took cameras to record their stories.

Snapshots from homesteaders and tourists are smaller but no less compelling than the grand, early photos of the West. Tourists captured a more personal West. Their pictures of mountains and gorges include friends and loved ones. They show a slightly different America—a land that offered infinite possibilities but was finite in nature. And they sent back the message that the early West would not last forever.

Settlers, too, depicted a wide-open country, but their pictures are tinged with isolation and loneliness. The Homestead Act, by its rules, obligated pioneer families to live apart, surrounded by what seemed like an unending prairie. Most of their photos document the hardships and challenges they faced. All show an American landscape that would inalterably change.

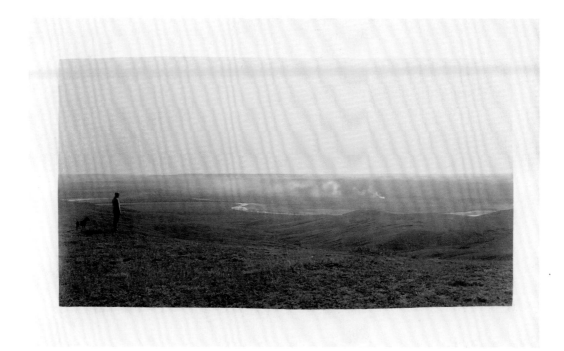

AFTER 1906
LAND SAKES: THE ADVENT OF POPULAR PHOTOGRAPHY PARALLELED THE LAST PIONEER PUSH ACROSS THE GREAT PLAINS. "IN THE UNITED STATES THERE IS MORE SPACE WHERE NOBODY IS THAN WHERE ANYBODY IS," WROTE GERTRUDE STEIN. "THAT IS WHAT MAKES AMERICA WHAT IT IS."

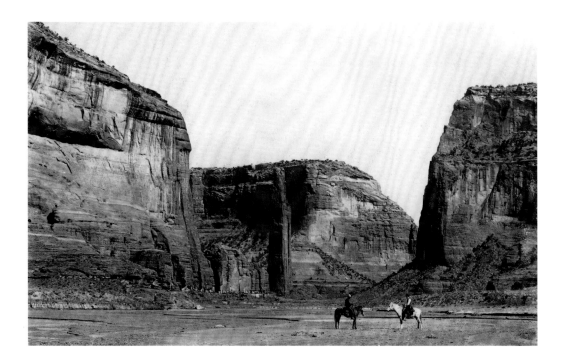

AFTER 1906—CANYON DE CHELLY, ARIZONA
DOWN IN THE VALLEY: SPIDER ROCKS RISES FROM THE FLOOR OF CANYON DE CHELLY IN THE NORTHEAST CORNER OF ARIZONA. THE CANYON, NAMED A NATIONAL MONUMENT IN 1931, IS STILL PART OF THE NAVAJO NATION.

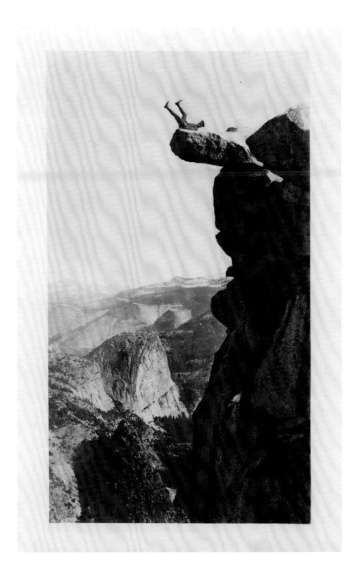

ABOUT 1910—YOSEMITE VALLEY, CALIFORNIA

ON THE EDGE OF THE WORLD: SOME OF THE GRANDEST EARLY PHOTOGRAPHS OF THE WEST WERE TAKEN FROM GLACIER POINT ROCK ABOVE THE YOSEMITE VALLEY. SNAPSHOOTERS WERE DRAWN TO THIS SPOT TO PROVE THEY WERE KINGS AND QUEENS OF THE MOUNTAIN.

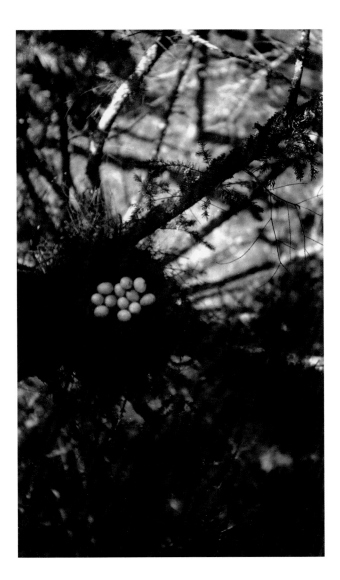

ABOUT 1900

Bird nest. Sixty-two feet above ground. Salem Heights.

SEE THE BIRDIES: TREETOP PHOTOGRAPHY WAS CONSIDERED SPORT AT THE TURN OF THE TWENTIETH CENTURY. "THE MAN WHO PERSISTS IN BEING CARELESS, IN THE TOPS OF TALL TREES, IS VERY APT TO HAVE A FUNERAL IN HIS FAMILY AT AN EARLY DATE," WARNED ONE PHOTO MAGAZINE.

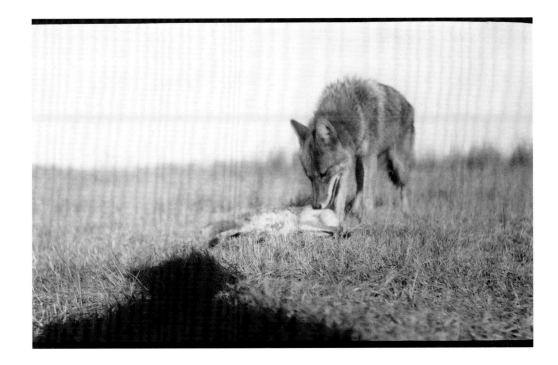

AFTER 1906
I RECKON IT'S REAL: WOLVES, CONSIDERED DANGEROUS KILLERS ON THE PRAIRIE, WERE TARGETED FOR EXTERMINATION IN 1915 WHEN THE FEDERAL GOVERNMENT PASSED A LAW PROVIDING A BOUNTY FOR THEIR KILLING. THE PROGRAM ENDED IN 1942—WITH ONLY A TINY PROPORTION OF THE POPULATION ALIVE.

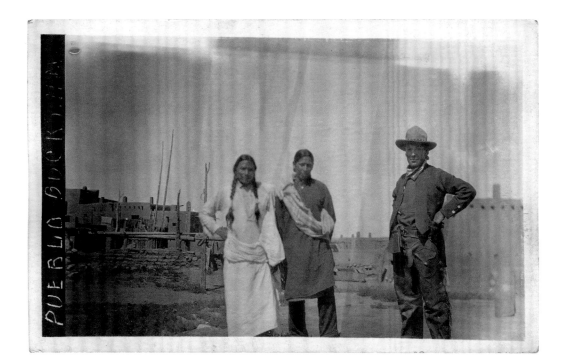

1915—TAOS, NEW MEXICO
THIS IS TO REMIND YOU: ROY G. WOODS VISITS NATIVE AMERICANS AT TAOS PUEBLO, THE OLDEST CONTINUOUSLY INHABITED COMMUNITY IN THE UNITED STATES. WOODS LEFT ILLINOIS SEEKING ADVENTURE. WITHIN DAYS OF THIS VISIT, HE WAS SHOT AND KILLED BY DRUNKEN LAWMEN. THE PHOTOGRAPH WAS TAKEN WITH AN AUTOGRAPHIC CAMERA, WHICH MADE IT POSSIBLE TO MAKE WRITTEN NOTES ON THE FILM.

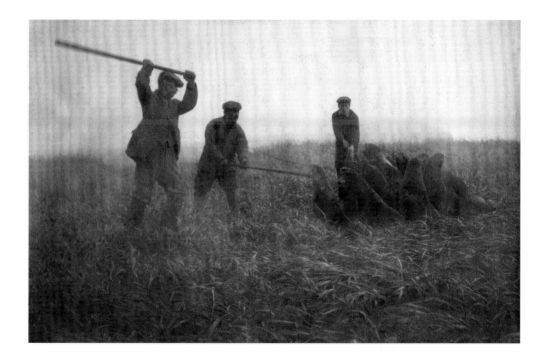

1915—ST. PAUL ISLAND, ALASKA
Killing Seals

DOES IT STILL LOOK LIKE IT USED TO?: HUNTERS USE CLUBS TO STUN AND KILL NORTHERN FUR SEALS FOR THEIR PELTS AS THE SEALS APPROACH THE ISLANDS OF SAINT GEORGE AND SAINT PAUL IN THE BERING SEA. IN 1910, THE FEDERAL GOVERNMENT TOOK CONTROL OF THE WORLD'S LARGEST SEAL COLONY, AND PERMITTED ONLY ISLAND NATIVES, KNOWN AS ALEUTS, TO CONTINUE HUNTING. THE COMMERCIAL SLAUGHTER OF FUR SEALS WAS CURTAILED ON SAINT GEORGE IN 1972 AND ON ST. PAUL IN 1984, BUT ALEUTS ARE STILL ALLOWED TO KILL SEVERAL HUNDRED SEALS EACH YEAR FOR SUBSISTENCE.

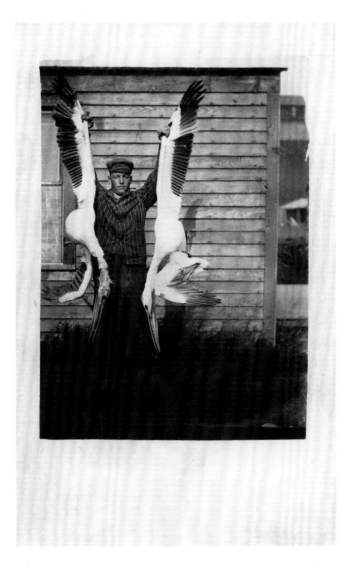

ABOUT 1915
PELICAN STEW: A HUNTER SHOWS HIS KILL. THE AMERICAN WHITE PELICAN, WITH ITS NINE-FOOT WING SPAN, IS NOW A PROTECTED
SPECIES IN CALIFORNIA.

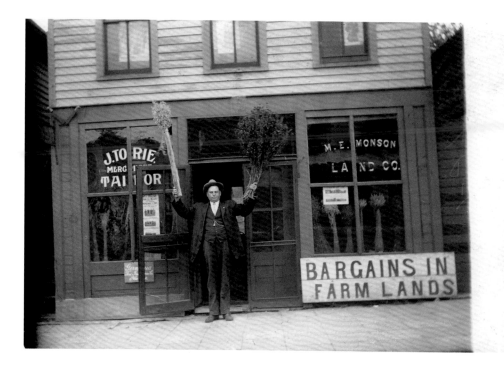

ABOUT 1915—CENTRAL MONTANA
WHAT A HARVEST: A REAL ESTATE AGENT CELEBRATES A LARGE YIELD, WHICH MEANT AN INCREASE IN LAND VALUES. "OFF THEY GO TO THE JUDITH BASIN IN MONTANA," THE SIGN IN THE WINDOW STATES. "ANOTHER WHALE OF A CROP."

[FOLLOWING PAGES] **HOME AGAIN, OH BOY:** HOMESTEADERS SHOW THEIR NEW RESIDENCES. THE HOMESTEAD ACT REQUIRED AMERICANS TO LIVE FIVE YEARS ON IMPROVED LAND TO QUALIFY FOR 160 ACRES OF FREE LAND. MOST CHOSE TO BUILD TAR PAPER SHACKS BECAUSE THEY WERE CHEAP AND EASY TO CONSTRUCT. OTHERS CHOSE TO BUILD WITH SOD, SOMETHING PLENTIFUL AND FREE. "THIS IS MY HOUSE," WROTE ONE MAN IN ELDON, SOUTH DAKOTA. "AIN'T IT A DANDY."

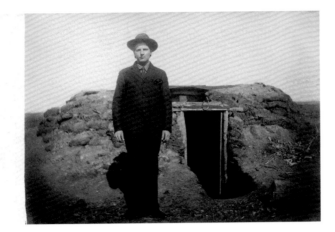

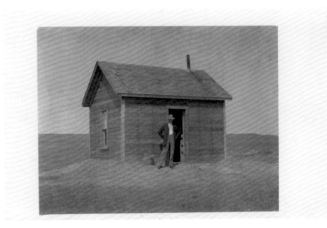

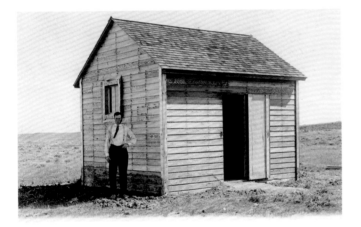

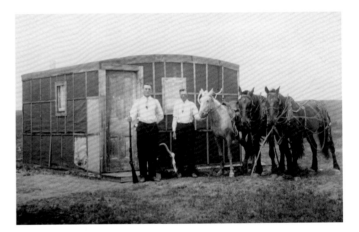

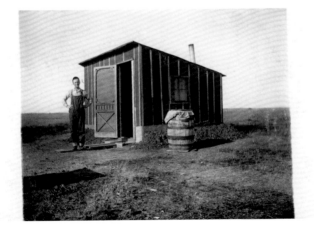

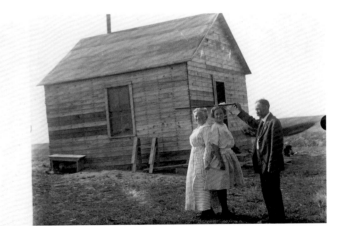

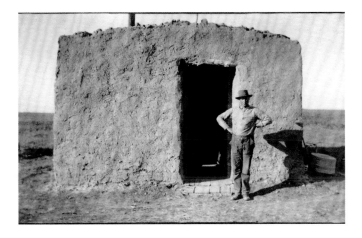

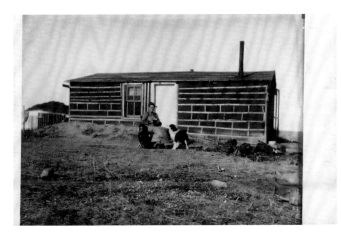

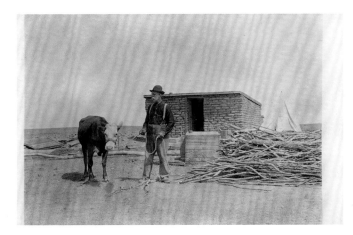

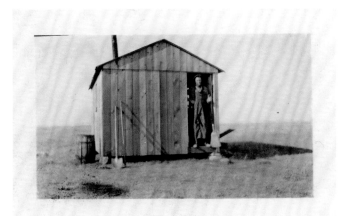

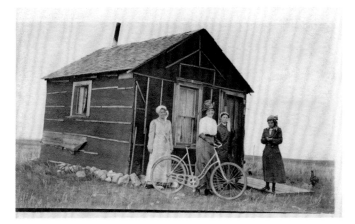

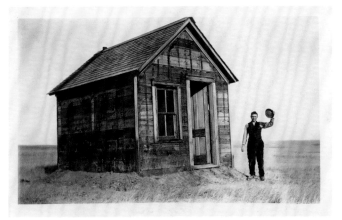

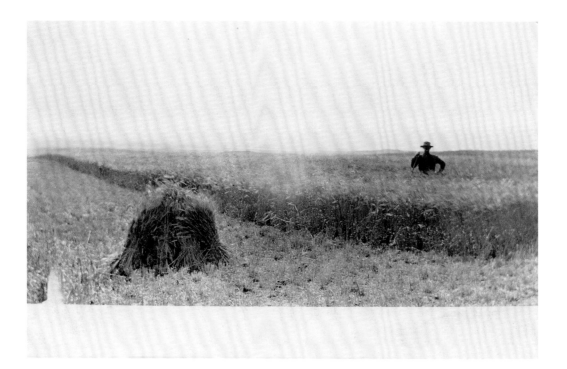

1914—SOUTH DAKOTA

Hello Frank. This is a picture of the wheat on my railroad land. We have eight stacks of wheat. I used 141 pounds of twine on 40-acres. I will have two stacks of oats and one of rye. I'll send you some more of the crop later. Corn is short. The girls have all kinds of fun, taking pictures. I would just like to catch you in Delmont. We are all well but me. I have to work so hard. Ed.

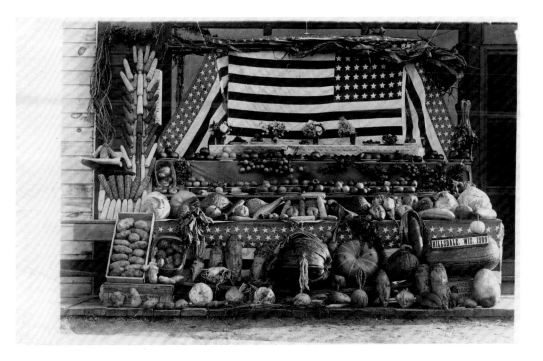

1909—HILLSDALE, WISCONSIN
OUR BOUNTY: THE AGRICULTURAL PROSPERITY OF THE WEST MEETS THE SURGING POPULATION OF THE MIDWEST.

'Back To Work Again'

The siren sound of the city called to those who lived on farms and to those who came to America in search of a better life. In 1890, almost two of every three Americans resided on farms. Thirty years later, more than half lived in cities and small towns. Thrust from rural life because of drought, blight, and mechanization, and lured to cities by jobs, nightlife, and excitement, few ever left. "How 'ya gonna keep 'em down on the farm after they've seen Paree?" asked Walter Donaldson in his 1919 hit song. His question was not just directed to the doughboys returning from France, but to all who tasted the big city.

During the first decade or so of the snapshot era, amateurs considered America's crowded cities unworthy of their art—preferring to focus on the pastoral beauty of the countryside. So much so that few snapshots can be found of nineteenth-century urban life. All that changed around the turn of the century when photographer Alfred Stieglitz demonstrated that the new metropolises offered attractive settings. Among his most popular pictorial images were New York's Fifth Avenue slush, the Harlem streetcar, and the New York Central train yard. Stieglitz, a serious artist, was not a snapshooter. In fact, he demeaned "button pressers" who "photographed by the yard." While he usually used a large-format camera, he also appreciated the spontaneity of the hand camera and understood its potential. Stieglitz demonstrated the possibilities of the snapshot camera and of the city as subject. And he convinced amateurs they could find beauty all around.

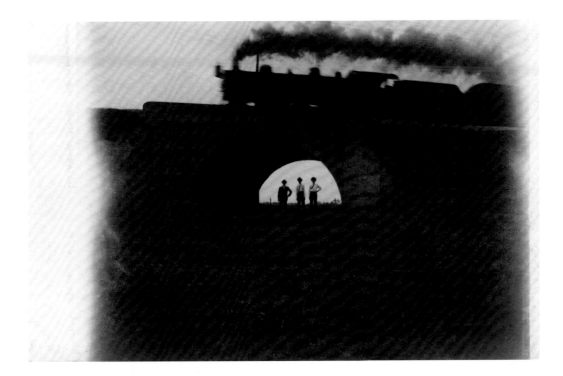

ABOUT 1915

HEAR THAT WHISTLE BLOW: TRAINS TWICE CHANGED THE AMERICAN LANDSCAPE. THEY HELPED CREATE THRIVING SMALL TOWNS IN FARMING COMMUNITIES, AND THEN OFFERED A ROUTE OUT OF TOWN TO BIG CITIES.

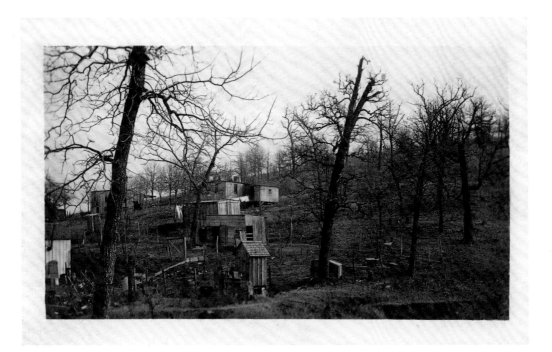

ABOUT 1915
JUST PLAIN FOLK: SHACKS DOT A TINY HILLSIDE COMMUNITY. THE SIMPLE, TRADITIONAL VALUES OF RURAL LIFE ARE STILL VALUED IN AMERICAN CULTURE, DESPITE THE FACT THAT MOST AMERICANS LIVE IN CITIES AND SUBURBS.

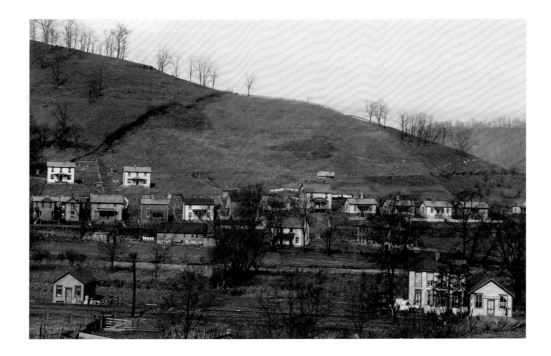

ABOUT 1920—NEFFS, OHIO
AIN'T IT A SHAME: THE COAL MINING TOWN OF NEFFS, IN THE SOUTHEAST CORNER OF OHIO. AN EXPLOSION IN THE WILLOW GROVE MINE NEAR NEFFS KILLED SEVENTY-TWO MINERS IN ONE OF THE NATION'S DEADLIEST MINE DISASTERS.

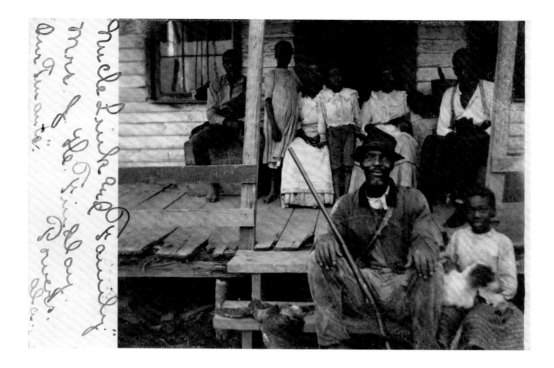

ABOUT 1910—POWERS, ALABAMA
UNCLE LINK'S FAMILY: THE POVERTY OF THE RURAL SOUTH SET THE STAGE FOR THE FIRST GREAT MIGRATION, AS MORE THAN 1 MILLION AFRICAN AMERICANS MOVED TO THE INDUSTRIAL CITIES OF THE NORTH DURING THE EARLY DECADES OF THE TWENTIETH CENTURY. POWERS IS IN HALE COUNTY, WHERE PHOTOGRAPHER WALKER EVANS COLLABORATED WITH WRITER JAMES AGEE TO PRODUCE THE BOOK *LET US NOW PRAISE FAMOUS MEN*.

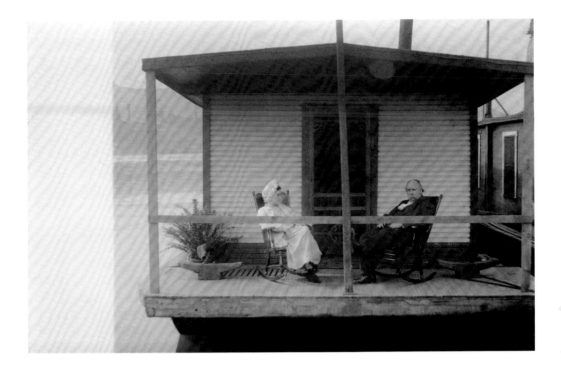

ABOUT 1910

DAD GUM IT, THE WATER IS WET: HOUSEBOATS WERE THE LAST REFUGE FOR THE POOR AND ADVENTUROUS IN SUCH PLACES AS NEW YORK, CHICAGO, NEW ORLEANS, AND SEATTLE. MOST WERE PRIMITIVE AND HOMEMADE, AND FEW HAD RUNNING WATER OR ELECTRICITY. CITY OFFICIALS DISDAINED THE "RIVER RATS" WHO LIVED ON HOUSEBOATS, NO DOUBT BECAUSE THEY PAID NO PROPERTY TAX.

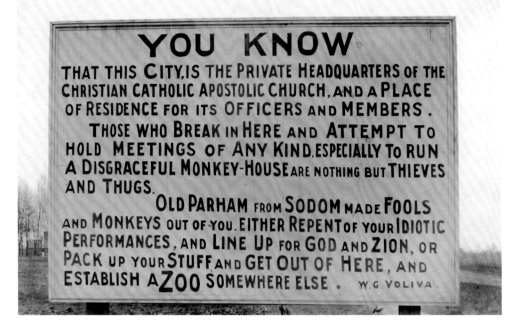

ABOUT 1915—ZION, ILLINOIS
LET THE WORLD GO BY: A SIGN POSTED IN THE RELIGIOUS COMMUNITY OF ZION BY WILBUR GLENN VOLIVA, ITS LEADER FROM 1906 THROUGH THE 1930S. VOLIVA BELIEVED THE EARTH WAS "FLAT AS A PANCAKE," A VIEW HE HELD ONTO EVEN AFTER AN AROUND-THE-WORLD CRUISE.

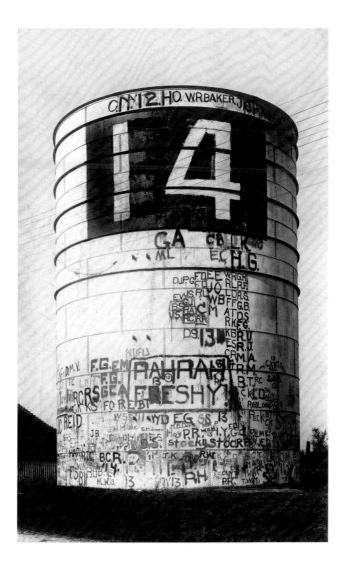

1911—WEST LAFAYETTE, INDIANA

At Purdue. Back to work again. Everything seems natural. I hope you are all well. Eugene.

A SIGHT SEEN: WATER TANKS SERVE AS A TOWN'S ROSETTA STONE.

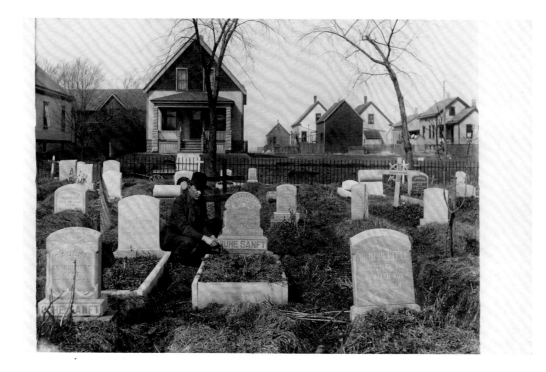

ABOUT 1915—MILWAUKEE, WISCONSIN
DULY NOTED: THE TOMBSTONE OF GUSTAV MECH, A GARBAGE COLLECTOR WHO FELL TO HIS DEATH FROM HIS WAGON. MECH'S HEAD WAS CRUSHED BY THE WHEEL. "FRIENDS CARRIED HIM INTO EQUITZ'S SALOON," WROTE POLICEMAN WILLIAM BRAMWELL SIZER IN HIS 1902 DIARY. "I CALLED THE WEST SIDE WAGON—TOOK HIM TO EMERGENCY HOSPITAL." MECH DIED THE NEXT DAY. THE TOMBSTONE READS "GENTLY RESTING" IN GERMAN.

1918—CHAMPAIGN OR URBANA, ILLINOIS
GOOD OLD DAZE: THE GAME OF STICKBALL, FROM A PHOTO ALBUM ENTITLED "MY DAYS AT ILLINOIS."

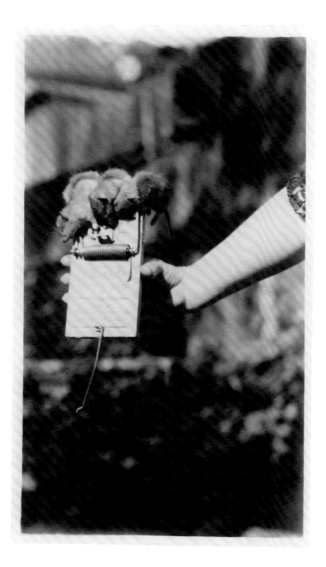

1922—LOS ANGELES, CALIFORNIA
PROOF POSITIVE: A PHOTO SUBMITTED TO A CONTEST SPONSORED BY THE VICTOR COMPANY TO SHOW HOW THE COMPANY'S RAT TRAPS COULD MAKE MULTIPLE KILLS. TWO YEARS LATER, CALIFORNIANS WERE BESIEGED BY A PLAGUE BELIEVED TO BE SPREAD BY RATS.

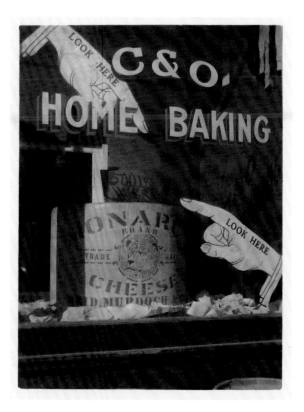

ABOUT 1920
IT PAYS TO ADVERTISE: A STOREFRONT DISPLAY SERVES AS A STAGE THAT BECKONS SHOPPERS.

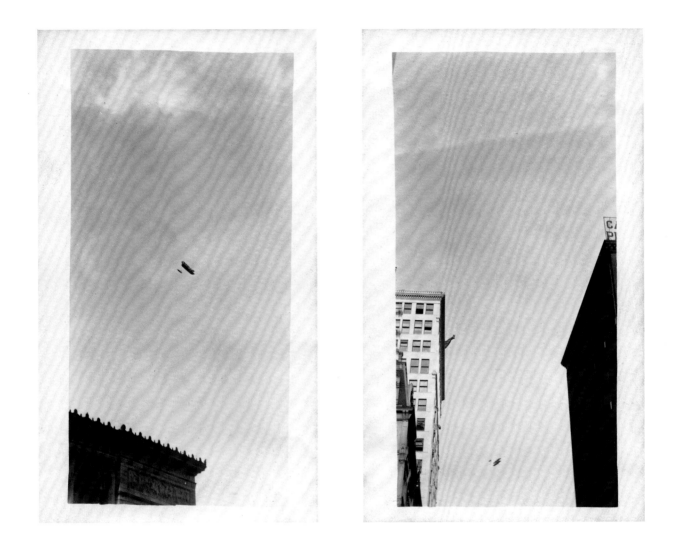

AUGUST 1911—CHICAGO, ILLINOIS
[LEFT:] *The Great Aeroplane Exposition. A Wright biplane over Art Institute.*
[RIGHT:] *The Railway Exchange, east on Jackson Boulevard.*

SHOW STOPPERS: WILBUR AND ORVILLE WRIGHT DID NOT FLY IN THE EIGHT-DAY INTERNATIONAL AVIATION MEET, BUT A DOZEN MEMBERS OF THEIR FLYING TEAM TOOK TO THE AIR. THE STAR OF THE MEET WAS INDEPENDENT FLYER LINCOLN BEACHEY, WHO SPIRALED HIGHER AND HIGHER UP TO TWO MILES ABOVE CHICAGO'S GRANT PARK UNTIL HIS PLANE RAN OUT OF GAS. HE THEN GLIDED BACK TO EARTH. SAID ORVILLE: "AN AEROPLANE IN THE HANDS OF LINCOLN BEACHEY IS POETRY."

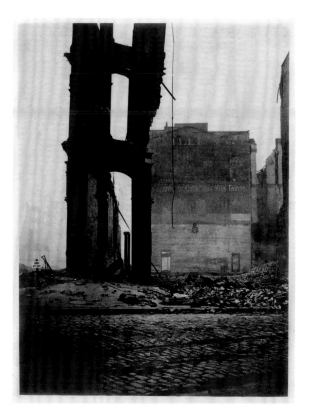

1906 SAN FRANCISCO, CALIFORNIA
Market Street

ALL THAT REMAINS: RUINS SMOLDER AFTER THE EARTHQUAKE AND FIRE THAT LEVELED A LARGE PORTION OF SAN FRANCISCO. THOUSANDS OF PHOTOGRAPHS, BY PROFESSIONALS AND AMATEURS, WERE TAKEN DURING THE CATASTROPHE, WHICH LEFT AT LEAST 500 PEOPLE DEAD AND ABOUT 200,000 HOMELESS.

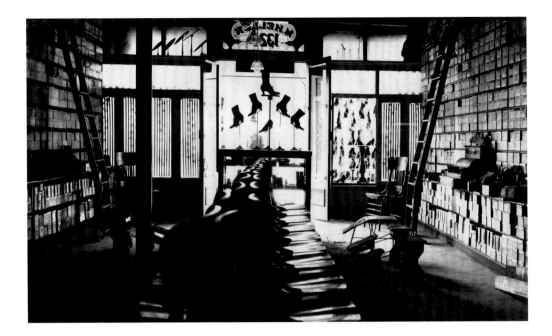

ABOUT 1910

SO EASY ON THE FEET: DRAMA OF THE FOOTWEAR STORE OF YESTERYEAR—WITH WALLS OF SHOES AND CEILING-HIGH LADDERS.
POPULAR SHOES OF THE DAY: FUR-TRIMMED VAMP JULIETS, WAVETOPS, AND BOUDOIR SLIPPERS.

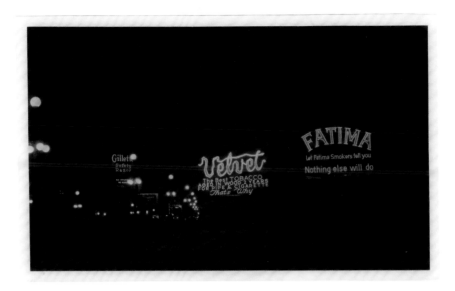

AROUND 1923—ATLANTIC CITY, NEW JERSEY
THE NIGHT SKY: ELECTRIC SIGNS BECAME PART OF THE URBAN LANDSCAPE SOON AFTER THEIR INTRODUCTION IN THE 1890S. NOVELIST THEODORE DREISER, IN *SISTER CARRIE*, CALLED THEM "FIRE SIGNS." SOME WERE SO ELABORATE THEY DREW CROWDS TO WATCH THEM FLASH ON AND OFF.

'It Is So Lonesome Here'

Visit most any antique show or flea market in America and you'll find boxes labeled "Instant Ancestors." Inside are photographs of people—long-lost relatives who have been orphaned by divorce, death, time, or a simple lack of space. Usually bought in bulk as part of an estate, they linger in the back of stores. Waiting to be sold for a buck or two, they tell stories. Of what we wore, where we traveled, and what we cared about.

Life. Death. Hope. Family. There is history here—sometimes even written on the back. A man nearly dies in a hospital. Two brothers are committed to a mental institution. Even without words, these pictures talk. About an Age of Confidence, when mustached men in starched shirts and bowler hats posed munificently, and women reigned in a world of sublimity—or so it seemed. About an Age of Reform, when men headed Over There to save the world, and women realized rights never dreamed by their mothers.

The people here were defined by what they did. From the banker to the telephone operator, they dressed in uniforms. The straight-laced Victorian life of the nineteenth century vanished quickly in the 1900s, but not the work ethic. Change came, but people kept their place. For men, wristwatches replaced pocket watches, and cigarettes replaced pipes. And for women, powder and lipstick replaced decades-old taboos, and ankle-length hems started to rise. But life went on as it had. It's all there—in those boxes.

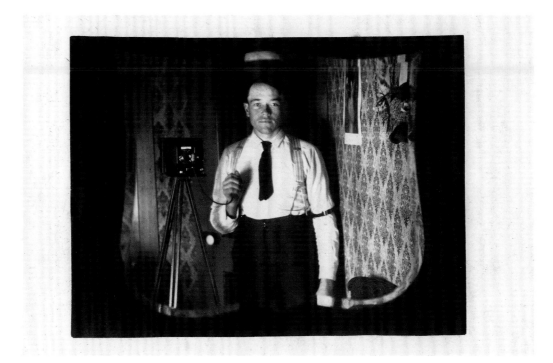

OCTOBER 31, 1910—PLAINVIEW, NEBRASKA
I hope you won't laugh yourself sick at the picture on this card, it is only a picture of myself in a mirror taken by myself.

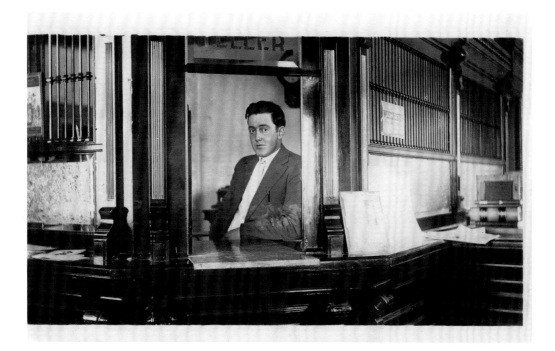

ABOUT 1920
BANKER'S HOLIDAY: ALTHOUGH THE 1920S WERE BOOM YEARS, THE NUMBER OF BANKS DECREASED. FARM WOES CAUSED HALF THE RURAL BANKS TO FAIL, AND THE 1929 STOCK MARKET CRASH WREAKED HAVOC ON CITY BANKS. THE FAILURES CAUSED DISTRUST, WHICH BEGAN TO LESSEN IN 1933 WHEN THE FEDERAL GOVERNMENT INSURED BANK DEPOSITS. "I CAN ASSURE YOU THAT IT IS SAFER TO KEEP YOUR MONEY IN A REOPENED BANK THAN UNDER THE MATTRESS," PRESIDENT FRANKLIN DELANO ROOSEVELT TOLD AMERICANS IN A FIRESIDE CHAT. PEOPLE LISTENED.

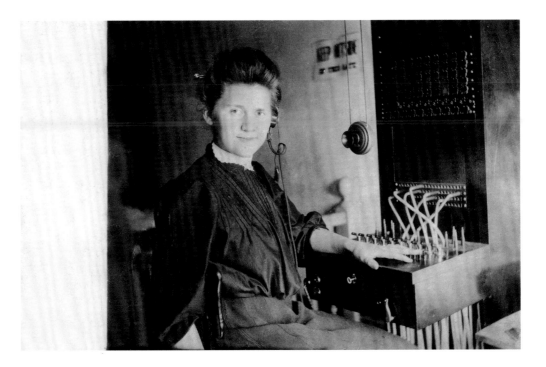

ABOUT 1920
Wisconsin rural exchange operator

VOICE WITH A SMILE: TELEPHONE OPERATORS CONNECTED CUSTOMERS BY USE OF A SWITCHBOARD, AND SERVED AS THE HEART OF A COMMUNITY—GIVING OUT SUCH INFORMATION AS THE TIME, WEATHER, NEWS, SPORTS SCORES, AND LOCAL GOSSIP.

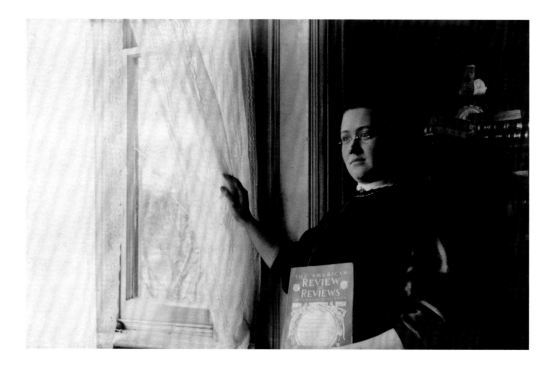

ABOUT 1915
THE THINKER: A WOMAN HOLDS AN ISSUE OF *THE AMERICAN REVIEW OF REVIEWS*, AN INFLUENTIAL, REFORM-MINDED MONTHLY THAT EMBRACED THE IDEA OF PROGRESSIVISM. PROGRESSIVE REFORMERS WORKED TO ELIMINATE POLITICAL CORRUPTION, REDUCE THE POWER OF BUSINESS MONOPOLIES, AND IMPROVE THE LIVES OF THE POOR.

ABOUT 1920
NOBODY'S FOOL: COLLEGE ENROLLMENT DOUBLED DURING THE 1920S DESPITE RESTRICTIONS BY TOPNOTCH SCHOOLS ON AFRICAN AMERICANS AS WELL AS QUOTAS ON JEWS AND "NEW IMMIGRANTS." ASIANS HAD A TOUGH TIME EVEN ENTERING THE UNITED STATES— BANNED BY A SERIES OF FEDERAL LAWS STARTING WITH THE CHINESE EXCLUSION ACT OF 1882. JAPANESE WERE EXCLUDED, TOO.

ABOUT 1920
THE SKIN YOU LOVE TO TOUCH: AMERICAN WOMEN BEGAN TO MOVE FROM CORSETS, THE "ARMOR OF RESPECTABILITY," TO GIRDLES AND BRASSIERES DURING THE 1910S.

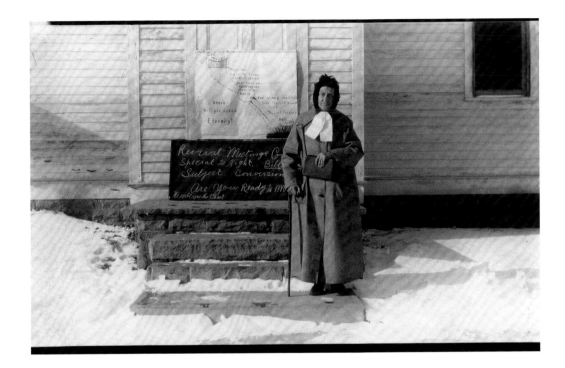

DECEMBER 27, 1923—LONGMONT, COLORADO

My dear Mary and family. This was taken xmas, and I am 82 in January. Many thanks for your beautiful Christmas card to me. I love it dearly. God bless you all with a Happy New Year is my prayer. Lovingly from Aunt Ruth N. H. Cassedy.

PRIM AND PROPER: CASSEDY, WIDOW OF A RANCHER, WAS A DEACONESS IN HER CHURCH.

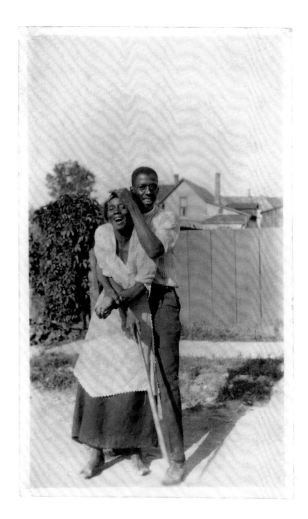

ABOUT 1915
HEE-HEE: "AMERICA IS THE LAST ABODE OF ROMANCE AND OTHER MEDIEVAL PHENOMENA," DECLARED NOVELIST ERIC LINKLATER.

JULY 3, 1906—UPLAND, PENNSYLVANIA
Mike and Bill are doing well. We will be taking them to Lewis Crozer Home for the Incurables in Upland, PA tomorrow. Jacob

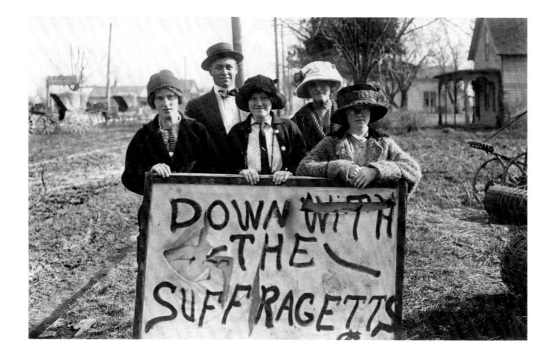

ABOUT 1915
READY LADIES: ANTI-SUFFRAGISTS, OR "ANTIS," DEMONSTRATE AGAINST A PROPOSED FEDERAL AMENDMENT GUARANTEEING THE RIGHT OF WOMEN TO VOTE. THEY ARGUED THAT A WOMAN'S PLACE SHOULD BE LIMITED TO DOMESTIC AFFAIRS AND THAT POLITICS WAS BEYOND HER UNDERSTANDING. WOMEN WON FULL VOTING RIGHTS IN 1920 AFTER A DECADES-LONG CAMPAIGN THAT INCLUDED PRISON HUNGER STRIKES DURING WORLD WAR I.

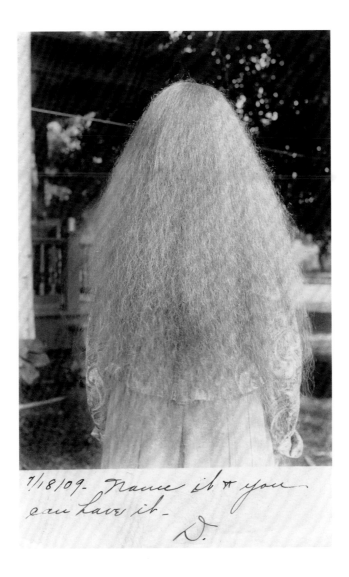

7/18/09- *Name it & you can have it.* D.

JULY 18, 1909

Dear Ollie—Are not going to falls. Plans changed. Will write to you later. Hope you will get to go to reservoir.

HECK, MY HAIR WON'T STAY COMBED: WOMEN'S HAIRSTYLES GREW SHORTER DURING THE EARLY DECADES OF THE TWENTIETH CENTURY, CULMINATING IN 1917 IN THE BOB. BUT VICTORIAN-STYLE FREE-FLOWING LOCKS CONTINUED TO BE APPRECIATED. LONG-HAIR CONTESTS WERE POPULAR STATE FAIR ATTRACTIONS THROUGHOUT MUCH OF THE CENTURY.

AUGUST 9, 1914—ROCHESTER, MINNESOTA

Dear Cousin. This was taken in my room today. Had secondary hemorrhage last week. Doctor and two nurses worked over me 18 hours until they could get it stopped. I started up a short while today. Am gaining slow and I have tonsils removed and can only swallow. Liquids now. Write. It is so lonesome here. Best to all. Your cousin. Jack Gibson.

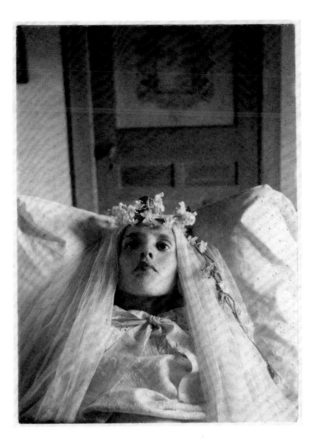

ABOUT 1910
BUT NOT FORGOTTEN: POSTMORTEM PHOTOS WERE SOMETIMES THE ONLY DOCUMENTATION OF AN INFANT OR SMALL CHILD. PICTURES WERE USUALLY TAKEN IN THE FORMAL PARLOR OF A FAMILY'S HOME, WHERE FUNERALS WERE HELD DURING THE EARLY PART OF THE CENTURY. AS MORTUARIES BECAME MORE ACCEPTED, THE HOME PARLOR BECAME KNOWN AS THE "LIVING ROOM."

The Painted World

Until the development of color photography in the 1930s, most Americans had to settle for black-and-white views of the world. But there was an exception. Some snapshooters colored their pictures, using kits from camera shops and department stores to create images of their own.

The colors—transparent oil paints or watercolors—were loud and not always accurate, but hand-colored photographs have a charm of their own. They combine the machinelike qualities of a photo print with the homemade qualities of painting. The tints give us a sense of a dreamy world rooted in reality.

Colors were applied using a cotton wad, and shading was achieved by rubbing down the colors. Coloring techniques reflected the taste of the creator. Sometimes photo-artists attempted to recreate actual colors. Sometimes they took poetic license, perhaps drawing attention to their favorite parts of a picture.

To make the process as simple as possible, manufacturers warned that colors should not be mixed, and left detailed instructions on what each color represented. Marshall's Photo Colors, for instance, recommended ultramarine blue for skies, viridian for water, and raw sienna for roads or old wood. Now what could go wrong?

Because the coloring of photographs was time-consuming and required a detailed eye, hand-colored pictures were often the most treasured of snapshots. Although not as literal as black-and-whites, they depict how we wanted to see the world around us.

What follows is a gallery of hand-colored photography from the 1920s and 1930s.

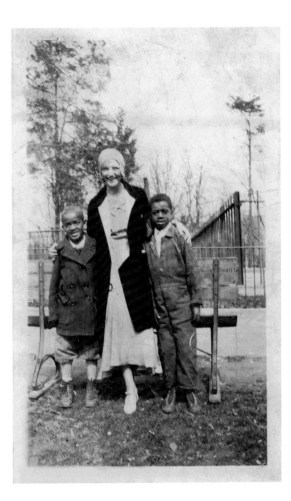

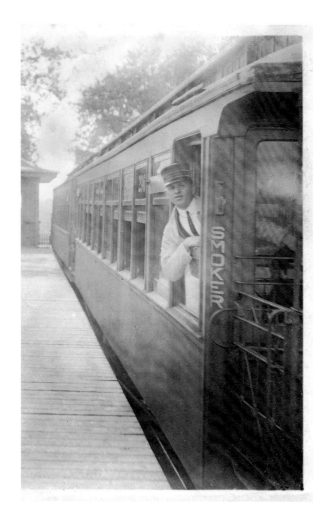

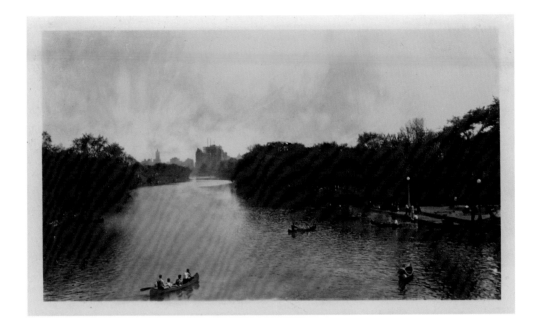

'The Night He Was Killed'

The Great War, as it was called, broke out in 1914, and raged across Europe for nearly three years until the United States joined the Allied Forces. World War I was the first to be documented by official photographers—and by soldiers themselves. Military regulations prohibited G.I.s from taking personal photos on the front, but thousands ignored the rule. The vest-pocket camera was marketed as "the Soldier's Kodak Camera" throughout the world. "You can load it much as you load a rifle," the company advertised. Fighting men from every country rushed to the front armed with cameras. American soldiers, who left to fight with such glory, had an irresistible urge to record their adventures abroad. But the reality of war—the death-stained trenches and flimsy airplanes—soon filled their photos with horror.

Unlike official photographers, who attempt to show large battles and aerial fights, line soldiers showed small moments—often the comrades they met and lost. For both amateurs and pros, the War to End All Wars was a particular challenge because it was fought with little protection. "There is no such thing as making pictures from a place of safety," wrote Albert K. Dawson, an official photographer for the Allies. "No man-built defense would save you from one of the big shells—say 30- or 35-centimeter—should it strike near where you are standing." But photograph they did.

America got out of the World War I with less cost, by comparison. The war ended in little more than a year with 117,000 American casualties—out of 20 million total. Now, for the first time, the nation found itself on top of the world.

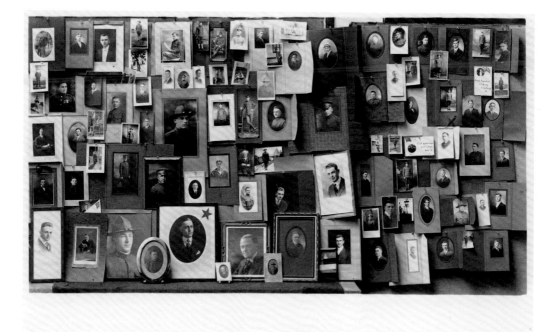

ABOUT 1918
HONOR TO THE BOYS: AMERICANS CREATED SHRINES TO REMEMBER THE LOCAL SOLDIERS WHO SERVED ABROAD. THIS COLLECTION IS MADE UP OF PHOTOS TAKEN BY AMATEURS AND PROFESSIONALS.

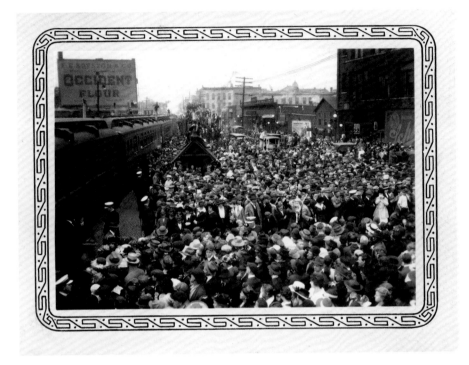

SEPTEMBER 13, 1917—AURORA, ILLINOIS
THE VERY LEAST A CITY COULD DO: ABOUT 10,000 PEOPLE GATHER AT THE AURORA TRAIN STATION TO BID FAREWELL TO 367 MEMBERS OF THE ILLINOIS NATIONAL GUARD AS THEY LEFT FOR TEXAS EN ROUTE TO FRANCE. WORRIED THAT THE SOLDIERS WOULD NOT BE ABLE TO AFFORD PROPER MEALS ON THEIR STIPEND OF 40 CENTS A DAY, RESIDENTS PACKED THEM 200 POUNDS OF MEAT, 608 LOAVES OF BREAD, 12 GALLONS OF PICKLES, AND GAVE THEM $25 TO BUY HOT COFFEE ON THE FIVE-DAY TRIP.

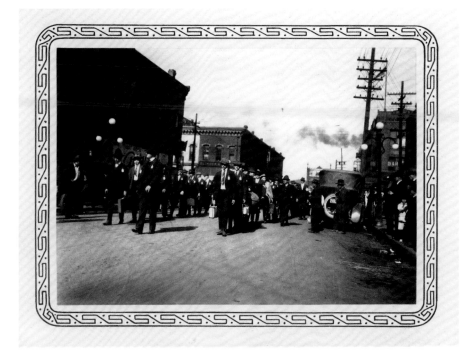

SEPTEMBER 13, 1917—AURORA, ILLINOIS
HELLO, I MUST BE GOING: THAT EVENING, A PARADE WAS HELD TO HONOR ANOTHER 190 ARMY DRAFTEES WHO WERE TO LEAVE SHORTLY FOR BASIC TRAINING. AFTER MARCHING THROUGH TOWN, THE RECRUITS GATHERED AT A THEATER, WHERE THEY WERE TREATED TO A LIVE PERFORMANCE BY THE MARX BROTHERS. SAID ONE WELL-WISHER: "THE PROFESSION OF THE SOLDIER IS THE MOST ROMANTIC AND FASCINATING CALLING THAT MEN CAN ENGAGE IN."

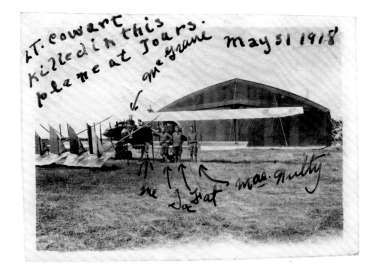

1918—TOURS-EN-VAUX, FRANCE

Lt. Cowarts plane, the one he flew to Tours the night he was killed.

HE NEVER RETURNED: ALFRED H. COWART DIED ON MAY 31 WHEN HIS CAUDRON G.4, A FRENCH BIPLANE, CRASHED. "ACCIDENT CAUSED BY THE DARKNESS," STATED THE ARMY AIR SERVICE REPORT. "PILOT EVIDENTLY LOST HIS WAY AND ALSO HAD TO BUCK HEAD WINDS AND CROSS WINDS, CAUSING HIM TO ARRIVE . . . AFTER DARK. IT IS EVIDENT THAT HE DID NOT SEE THE GROUND UNTIL TOO LATE."

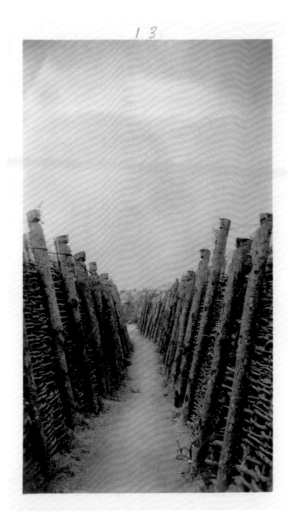

ABOUT 1918—FRANCE
Notice the workmanship of this French trench—and imagine the water in the springtime.

HELL'S HALF-ACRE: GERMANS AND ALLIED SOLDIERS BUILT 1,500 MILES OF TRENCHES ALONG THE WESTERN FRONT FROM 1914 TO 1918. ABOUT ONE-THIRD OF ALL SOLDIERS WHO FOUGHT ON THE FRONT WERE KILLED OR WOUNDED IN THE TRENCHES AND THE BARBED-WIRE NO-MAN'S LAND BETWEEN THEM. THIS PHOTO WAS TAKEN BY RAY E. WILLIAMS, OF THE AMERICAN AMBULANCE FIELD SERVICE.

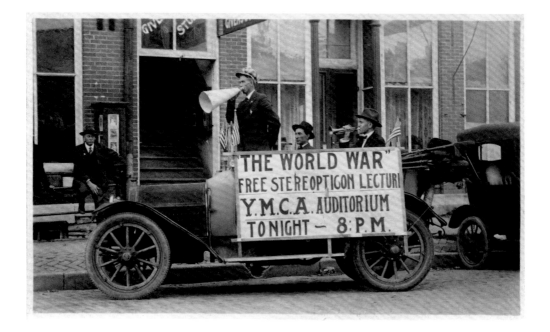

ABOUT 1918

THAT'S WHAT THE RED, WHITE, AND BLUE MEANS: THE STEREOPTICON, KNOWN AS A "MAGIC LANTERN," WAS AN EARLY SLIDE SHOW. AFTER AMERICA ENTERED THE WAR, PRESIDENT WOODROW WILSON BEGAN A MASSIVE PROPAGANDA CAMPAIGN, WHICH INCLUDED SHOWS AND LECTURES, TO KEEP UP PATRIOTIC SPIRIT. WILSON'S ADMINISTRATION ACTIVELY DISCOURAGED CRITICISM OF THE WAR.

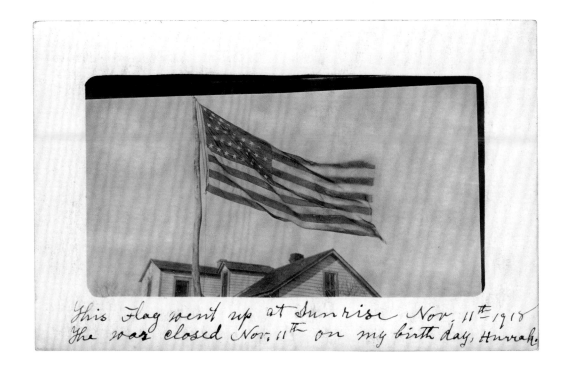

This Flag went up at Sunrise Nov. 11th 1918 The war closed Nov. 11th on my birth day, Hurrah.

NOVEMBER 13, 1918—ALPENA, SOUTH DAKOTA
Hurray the war is over, like the other war. I lived through it and I will try to live through the war with the flu. We all had it but did not know it ha ha. The weather is fine and the corn is the best ever had in Dakota or anywhere else, All Well. C. M. Gregge.

'I Was Hungry And Thirsty'

America during the 1920s and 1930s was a peculiar place.

It was a nation filled with superlatives—huge fortunes and titanic losses, social reform and social upheaval. People lived on the edge, and that sparked eccentricities.

F. Scott Fitzgerald saw it coming as early as 1920. "Here was a new generation," he wrote in *This Side of Paradise*, "a new generation dedicated more than the last to the fear of poverty and the worship of success, grown up to find all gods dead, all wars fought, all faiths in man shaken."

Histories of this period focus on the big stories—the boom and bust of the '20s, the gloom of the '30s, and the impending war. Snapshots give the inside report, of rabbit hunts and dust storms, back porches and back streets, county fairs and county courthouses. Here we see an old, weird America seeping into the nation's fabric. A regression as well as a depression.

Life picked up in the twenties: Americans ate sliced bread, danced the Charleston, and crowded around the radio. Some made fortunes; others bought on credit. But after the 1929 stock market crash, the Gatsby twenties seemed so far away. The Dust Bowl replaced Wall Street; the game of Monopoly replaced real monopolies, and those Charleston dances were replaced by longer, more grueling dances called marathons.

But for many, these were the years that America was most American. Years when Americans, flush from victory in Europe, felt all-powerful. Years when Americans, imbued with the moral idealism of Prohibition, felt most superior. And years when Americans struggled just to stay alive.

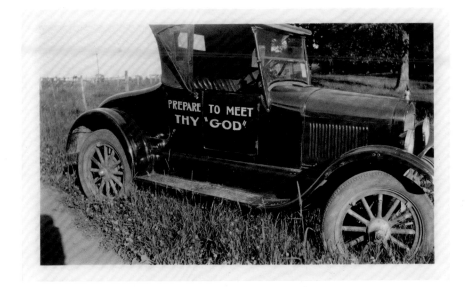

ABOUT 1930
FULL SPEED AHEAD: AMERICA'S INDUSTRIAL WORKHORSE, THE BRASS-NOSED FORD MODEL T, CARRIES THE WORD OF THE APOSTOLIC FAITH, AN EARLY PENTECOSTAL CHURCH.

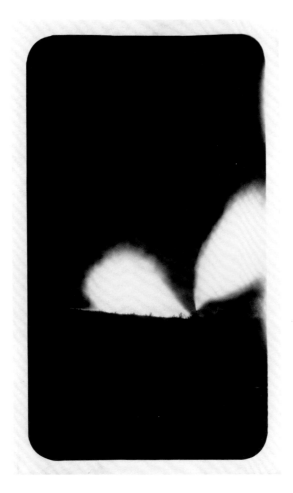

ABOUT 1930
WELL, LOOK AT THIS: CLOUDS DARKEN AS A TORNADO APPROACHES. AMERICA IS THE TORNADO CAPITAL OF THE WORLD. AN AVERAGE OF 260 PEOPLE PER YEAR WERE KILLED BY TWISTERS BETWEEN 1912 AND 1936, ALMOST FIVE TIMES THE AVERAGE OF TORNADO-RELATED DEATHS NOW. BETTER BUILDING CONSTRUCTION TODAY ACCOUNTS FOR THE DECREASE IN FATALITIES.

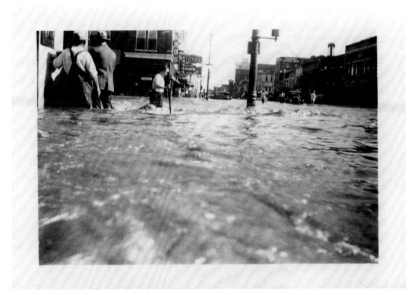

JULY 14, 1929—HUTCHINSON, KANSAS
HIGH-WATER MARK: FLOODWATERS RECEDE IN THE CENTRAL KANSAS TOWN OF HUTCHINSON. EVERY MEMBER OF THE NEARBY TOWN OF SAXMAN, POPULATION 135, HAD TO BE EVACUATED BY BOAT FROM THE TOWN'S CITY HALL.

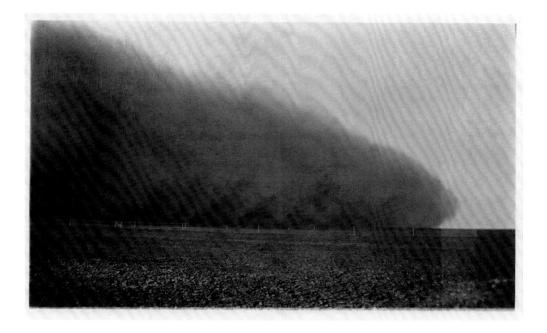

ABOUT 1932—OAKLEY, KANSAS

Guess I'll have to send you a card instead of a letter. I'm here sick in bed all day—Lulu.

NIGHT SKY AT NOON: DECADES OF TOPSOIL EROSION AND YEARS OF DROUGHT HELPED CREATE DUST STORMS, SOME ALMOST TWO MILES HIGH. THE WORST, A MIXTURE OF DIRT AND DUST THAT STARTED IN THE GREAT PLAINS, WERE CALLED "BLACK BLIZZARDS." FOR DAYS, THEY DARKENED CITIES AS FAR EAST AS NEW YORK CITY AND WASHINGTON, D.C.

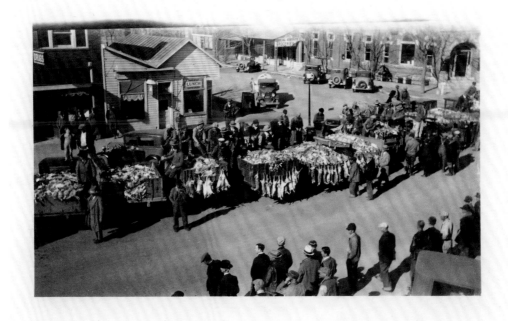

EARLY 1930S

UP THE ROAD, DOWN THE ROAD: HUNTERS RETURN FROM A HUGE COMMUNITY RABBIT DRIVE. THE ROUNDUPS WERE ORGANIZED BY COUNTIES, MOSTLY IN WESTERN NEBRASKA, WHICH WERE OVERRUN BY STARVING RABBITS. JACK RABBITS WERE SO PLENTIFUL IN KIMBALL COUNTY THAT THE COUNTY HISTORY REPORTED: "ON LOOKING OUT OVER THE PRAIRIE IT LOOKED LIKE THE GROUND WAS MOVING." EIGHT-HUNDRED HUNTERS WERE PAID BOUNTIES TO BRING BACK 100,000 EARS IN 1934. THEY CIRCLED HUGE SECTIONS OF LAND AND CONVERGED WITH SHOTGUNS, DRIVING THE RABBITS TOWARD THE CENTER, WHERE THEY WERE SHOT AND KILLED.

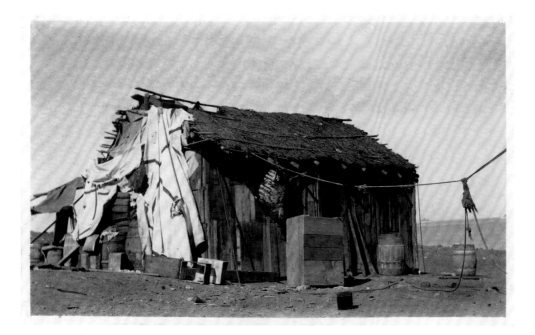

EARLY 1930S

I DON'T REMEMBER WHO OR WHEN: THE DROUGHT CAUSED ONE OF THE LARGEST MIGRATIONS IN UNITED STATES HISTORY—SWEEPING MORE THAN 2 MILLION MIGRANTS AND FARMERS FROM THEIR HOMES IN ARKANSAS, OKLAHOMA, KANSAS, COLORADO, AND OTHER PLAINS STATES TOWARD THE WEST COAST.

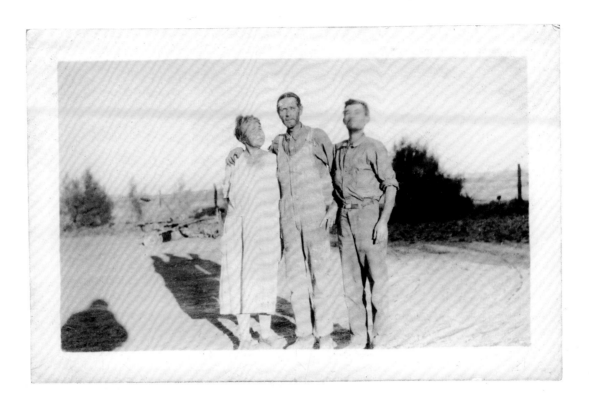

1930S—CALIFORNIA

These folks live 250 feet below sea level. They have a farm in the desert country around the Salton Sea, in the Imperial Valley, California. Extremely hot in summer. I was hungry and thirsty with exploring round the Salton Sea, and tried to buy a meal off them. They filled me up and refused money, so I took their pictures and sent them copies. The fellow on the right had been celebrating Armistice Day, and looks as if he felt dizzy in the head.

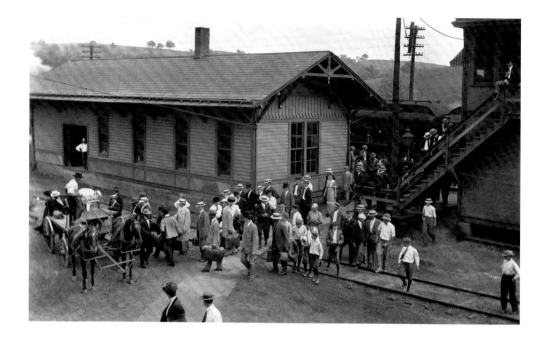

EARLY 1920S

WHAT DO YOU THINK OF THIS ?: AN AFRICAN AMERICAN BASEBALL TEAM IS GREETED UPON ITS ARRIVAL IN A SMALL TOWN. ORGANIZED BASEBALL FOR BLACKS STARTED IN 1920 WITH THE ESTABLISHMENT OF THE NEGRO NATIONAL LEAGUE AND NEGRO SOUTHERN LEAGUE. PLAYERS SUPPLEMENTED THEIR INCOMES BY PLAYING EXHIBITION GAMES ALONG TRAVEL ROUTES. NEGRO LEAGUE BASEBALL CONTINUED THROUGH 1952, FIVE YEARS AFTER JACKIE ROBINSON BREACHED THE MAJOR LEAGUE COLOR LINE.

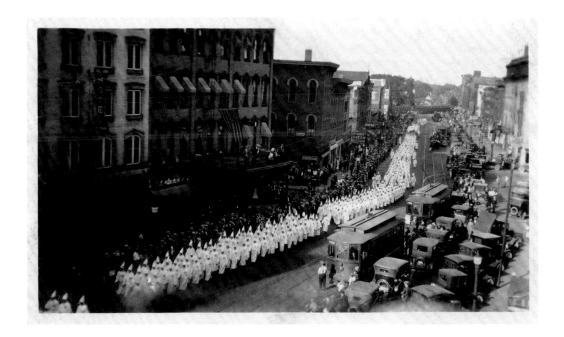

ABOUT 1922

YOU KNOW US: THE KU KLUX KLAN REACHED ITS PEAK IN THE EARLY 1920S WITH BETWEEN 4 AND 6 MILLION MEMBERS. THE KKK PREACHED HATRED TOWARD BLACKS, HOMOSEXUALS, JEWS, AND CATHOLICS, AS WELL AS DISDAIN AGAINST UNIONS, SMOKING, DANCING, AND PROSTITUTION. "I REMEMBER GOING TO SLEEP AS A GIRL AND HEARING THE KU KLUX KLAN RIDE AT NIGHT AND HEARING A LYNCHING AND BEING AFRAID THE HOUSE WOULD BURN DOWN," WROTE CIVIL RIGHTS ACTIVIST ROSA PARKS.

ABOUT 1920
RED, WHITE AND BLUE: THE PIG SLAUGHTER, AS AMERICAN AS APPLE PIE.

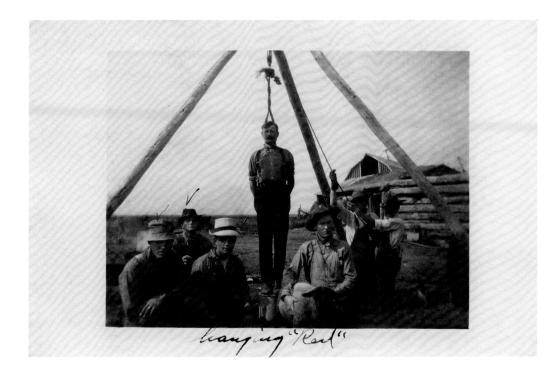

hanging "Red"

ABOUT 1920
GALLOWS HUMOR: LYNCHING, OR VIGILANTE MURDER, WAS PRIMARILY AN AMERICAN PRACTICE. UNTIL THE CIVIL WAR, GALLOWS WERE MOSTLY USED ON WHITES. AFTER THE FALL OF THE CONFEDERACY, THE "LYNCH-LAW" BECAME A KEY WEAPON USED BY WHITE SOUTHERNERS TO TERRORIZE BLACKS. BETWEEN 1882 AND 1951, MORE THAN 4,700 PEOPLE WERE LYNCHED IN THE UNITED STATES, ACCORDING TO A TUSKEGEE INSTITUTE STUDY. SOME 3,400 WERE AFRICAN AMERICANS.

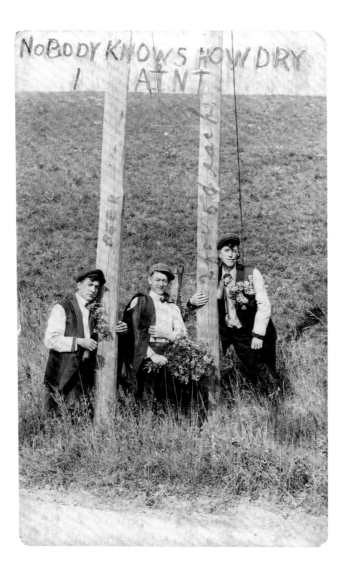

EARLY 1920S

Hello Otto. Must drop you a line and let you know we are all living yet. This is Oscar and Walter coming from a wedding. They went Saturday morning and came back Thursday morning. They were sober as they came home.

ALL WET: PROHIBITION, "THE NOBLE EXPERIMENT" THAT BANNED THE MANUFACTURE, SALE, OR TRANSPORTATION OF INTOXICATING LIQUORS, RAN FROM 1920 TO 1933. IT BEGAN WITH THE PASSAGE OF THE EIGHTEENTH AMENDMENT OF THE U.S. CONSTITUTION AND WAS ENDED BY THE TWENTY-FIRST AMENDMENT.

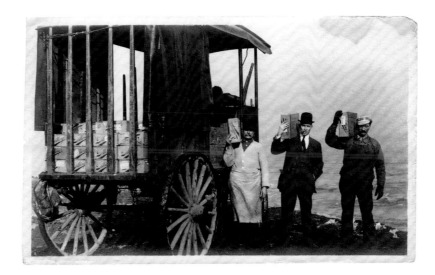

EARLY 1920S

A MYSTERY: WOODEN CRATES FROM THE DILLINGS CANDY COMPANY IN INDIANAPOLIS ARE TOSSED AWAY. FEDERAL AGENTS DID OCCASIONALLY RAID CANDY COMPANIES THAT USED TOO MUCH ALCOHOL IN THEIR BONBONS DURING THE PROHIBITION, BUT NO FEDERAL LAWSUIT WAS EVER FILED IN INDIANA AGAINST THE COMPANY.

ABOUT 1930
TIN-CAN TOURISTS: "WE'D RATHER DO WITHOUT CLOTHES THAN GIVE UP THE CAR," A MUNCIE, INDIANA, MOTHER OF NINE TOLD SOCIOLOGISTS ROBERT AND HELEN LYND IN THE 1929 BOOK *MIDDLETOWN.* WROTE HUMORIST WILL ROGERS: THE UNITED STATES IS THE ONLY NATION THAT WILL HEAD TO THE POORHOUSE IN A CAR.

ABOUT 1930
THE IDEA WAS SIMPLE: GASOLINE FROM CRUDE OIL MIXES WITH OXYGEN IN A COMBUSTION CHAMBER. GAS EXPANDS, WHICH PUSHES PISTONS, WHICH TURNS A CRANKSHAFT, WHICH CONNECTS TO A DRIVE SHAFT, WHICH POWERS FOUR WHEELS, WHICH REQUIRES ROADS, WHICH CHANGES THE FACE OF AMERICA. "WHY ON EARTH DO YOU NEED TO STUDY WHAT'S CHANGING THIS COUNTRY?" ANOTHER MUNCIE RESIDENT TOLD THE LYNDS. "I CAN TELL YOU WHAT'S HAPPENING IN FOUR LETTERS: A-U-T-O!"

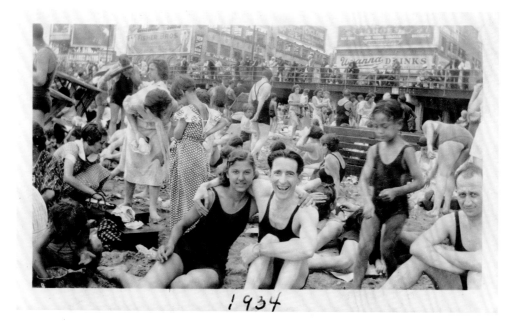

1934

1934—CONEY ISLAND, BROOKLYN
Margie and Paul.

ANYTHING GOES: DOZENS OF MEN WERE ARRESTED IN 1934 FOR LOWERING THEIR TOPS TO SHOW THEIR CHESTS AT THE CONEY ISLAND BEACH. SOME JUDGES DROPPED THE CHARGES; OTHERS FINED BATHERS $1. RULED MAGISTRATE JEANNETTE BRILL: "ALL OF YOU FELLOWS MAY BE ADONISES, BUT THERE ARE MANY PEOPLE WHO OBJECT TO SEEING SO MUCH OF THE HUMAN BODY EXPOSED."

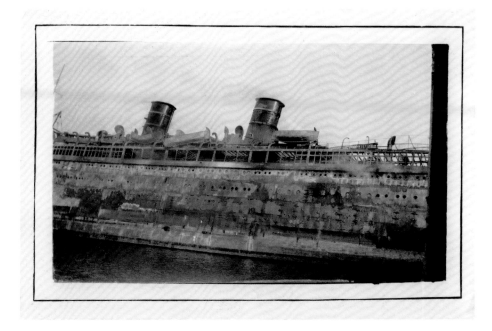

1934—ASBURY PARK, NEW JERSEY
ALL WASHED UP: THE LUXURY CRUISE SHIP MORRO CASTLE DRIFTED ASHORE AFTER CATCHING FIRE IN AN ATLANTIC OCEAN STORM ABOUT SIX MILES OUT AT SEA. SOME 134 PASSENGERS AND CREW MEMBERS WERE KILLED IN THE MYSTERIOUS FIRE. THE STILL SMOLDERING WRECK DRIFTED ASHORE BECOMING AN INSTANT TOURIST ATTRACTION FOR FIVE MONTHS.

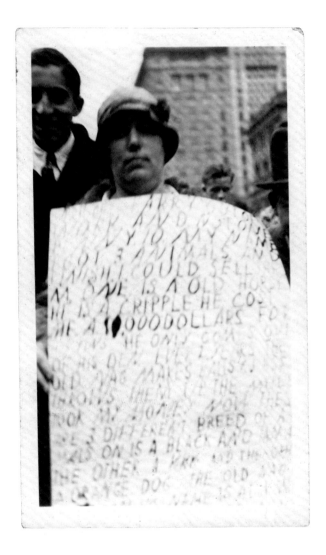

1930—NEW YORK CITY, NEW YORK

Bridget Farry, the chambermaid at the Park Central Hotel, N. Y. City, who saw Arnold Rothstein stagger from the room in which he was shot on Nov. 6, 1928. She was held in Tombs Prison for a number of months as a material witness by the police. She was paid for the time in custody but never returned to the hotel to work.

THE FIX IS IN: ARNOLD ROTHSTEIN, THE ACKNOWLEDGED MASTERMIND BEHIND THE 1919 BLACK SOX SCANDAL, WAS SHOT OVER A GAMBLING DEBT ON NOVEMBER 4, 1928, AND DIED TWO DAYS LATER. WITNESS BRIDGET FARRY REFUSED TO PROVIDE DAMAGING TESTIMONY AGAINST GAMBLER GEORGE MCMANUS, WHO WAS TRIED UNSUCCESSFULLY FOR THE MURDER. FERRY PICKETED CITY HALL IN 1930 AND AGAIN IN 1934 TO PROTEST THE WAY SHE WAS TREATED WHILE IN CUSTODY.

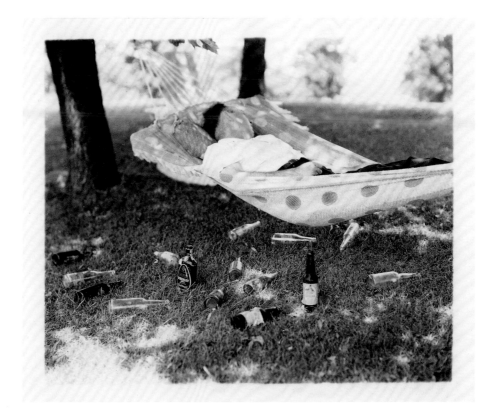

1930S

FAMILY BLACKMAIL: A FREQUENT POST-PROHIBITION GAG PHOTO INVOLVED A SEA OF BEER BOTTLES PLACED AROUND AN UNSUSPECTING NAPPER.

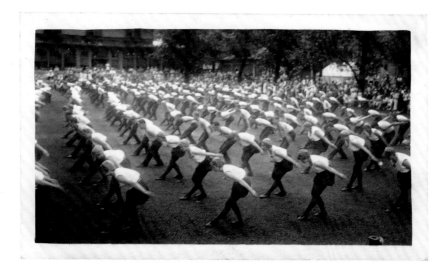

JUNE 16, 1935—CHICAGO, ILLINOIS
Mass drill of men and women at Pilsen Park.

TAKE A BOW: HUNDREDS OF GYMNASTS PERFORM AT THE ANNUAL SOKOL FESTIVAL. THE SOKOL MOVEMENT WAS A POPULAR FITNESS AND CULTURAL AWARENESS PROGRAM BROUGHT TO AMERICA BY EMIGRANTS FROM THE CZECH REPUBLICS. AT ONE TIME, CHICAGO WAS THE THIRD LARGEST CZECH CITY IN THE WORLD.

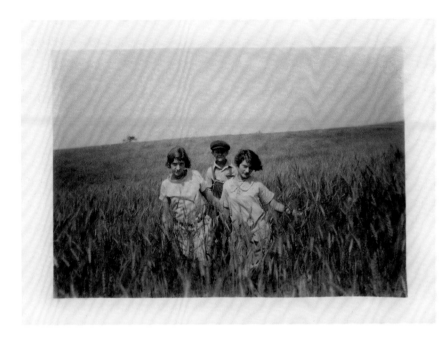

EARLY 1930S
AMBER WAVES: CHILDREN MEANDER THROUGH WHEAT FIELDS. GRAIN, PLANTED IN THE SPRING AND THE WINTER, WAS OFTEN THE FIRST CROP OF CHOICE AS SETTLERS MOVED WEST.

1935—BIRMINGHAM, ALABAMA
FLIP-FLOP: AFRICAN AMERICANS IN THE SOUTH TOOK THE BRUNT OF THE DEPRESSION AS GOVERNMENT POLICY TO REDUCE COTTON PRODUCTION PUT MANY OUT OF WORK. WHAT MENIAL LABOR THAT WAS LEFT WAS OFTEN GIVEN TO WHITES, WHO ALSO SOUGHT JOBS. LAND OWNERSHIP OFFERED LITTLE RELIEF: IN THE EARLY 1930S, ONLY ONE IN EVERY TEN BLACK TENANT FARMERS REPORTED A YEARLY PROFIT OF ANY KIND, ACCORDING TO A FISK UNIVERSITY STUDY.

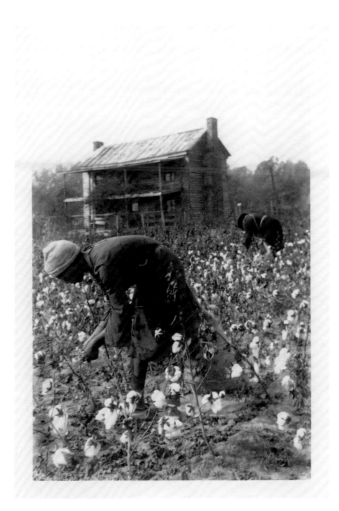

1930S
FIFTY CENTS A DAY: TENANT FARMING AND SHARECROPPING ALSO SUFFERED WHEN COTTON PRICES DROPPED IN THE EARLY THIRTIES. TWENTY YEARS LATER, ALMOST ALL COTTON PICKING WAS DONE BY MACHINES. BY THEN, MANY AFRICAN AMERICAN SHARECROPPERS HAD MOVED TO BIG CITIES.

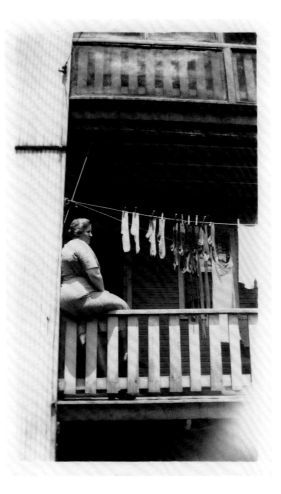

1930s
AT THE END OF OUR STRING: A VIEW THAT MANY NEW IMMIGRANTS HAD OF AMERICA. MULTI-FAMILY TENEMENTS, OFTEN CROWDED AND DIRTY, WERE THE FIRST HOMES OF THOSE ARRIVING FROM EUROPE AND ASIA, OR OF AFRICAN AMERICANS ARRIVING FROM THE SOUTH.

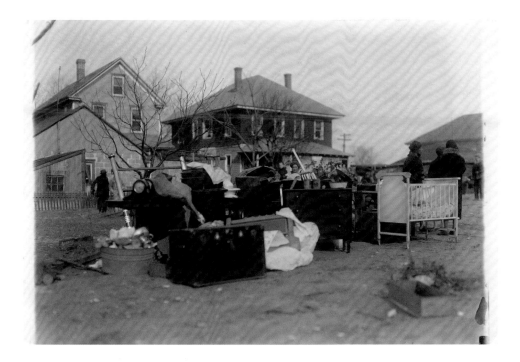

1932
OUT ON THE STREET: HUNDREDS OF COMMUNISTS IN NEW YORK CITY, CHICAGO, AND CLEVELAND MOUNTED MILITANT PROTESTS AGAINST EVICTIONS DURING THE EARLY YEARS OF THE DEPRESSION. ON A FEW OCCASIONS, SYMPATHIZERS EVEN MOVED THE BELONGINGS OF EVICTED FAMILIES BACK INTO APARTMENTS. THE TACTIC SOMETIMES WORKED BECAUSE LANDLORDS HAD TO PAY LAW ENFORCEMENT OFFICIALS TO CONDUCT ANOTHER EVICTION.

1930S

THE FORGOTTEN MAN: "HE WORKS, HE VOTES, GENERALLY HE PRAYS, BUT HE ALWAYS PAYS, YES, ABOVE ALL, HE ALWAYS PAYS," PRESIDENT FRANKLIN ROOSEVELT SAID OF HIS SYMBOLIC "FORGOTTEN MAN." WROTE ONE TO FDR IN 1935: "I ONLY WANTS A COMMON LIVING TO EXIST WITHOUT STARVING AND FREEZING TO DEATH."

1930S
JUST A LITTLE SMILE FOR YOU: BY THE EARLY THIRTIES, ALMOST ONE-FOURTH OF THE NATION WAS UNEMPLOYED, CAUSING THE MARRIAGE AND BIRTH RATES TO DROP THROUGH THE THE EARLY PART OF THE DECADE.

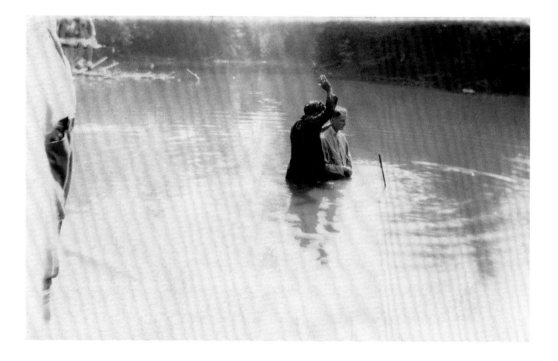

ABOUT 1930
WADE IN THE WATER: RELIGIOUS IMMERSIONS BECAME COMMON IN AMERICA STARTING IN THE 1890S, AND INCREASED DURING HARD ECONOMIC TIMES. ONE TENANT FARMER RECALLED HOW HIS PASTOR BAPTIZED FORTY OR FIFTY WOMEN AT A TIME. "AS THEY COME UP, HE'D PAT EACH ONE ON THE SHOULDER AND SAY, 'SISTER, YOU'RE SAVED.'"

"Praise ye unto the Lord" Amen

1930S

A SIMPLE PRAYER: AN OPINION SURVEY TAKEN IN 1939 FOUND THAT FARMERS AND SMALL TOWN RESIDENTS BELIEVED THAT INTEREST IN RELIGION WAS WANING. CITY RESIDENTS BELIEVED INTEREST WAS INCREASING.

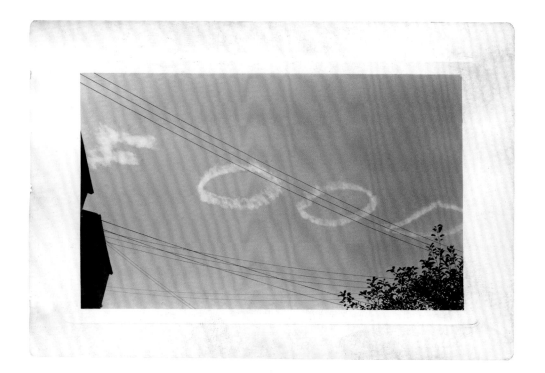

1930S

PIE IN THE SKY: THE IDEA OF USING WHITE SMOKE TO ADVERTISE WAS FIRST DEMONSTRATED ABOVE NEW YORK CITY'S TIMES SQUARE IN 1922 BY BRITISH CAPTAIN CYRIL TURNER. HE SPELLED OUT "HELLO USA CALL VANDERBILT 7200." FIFTY THOUSAND CALLED.

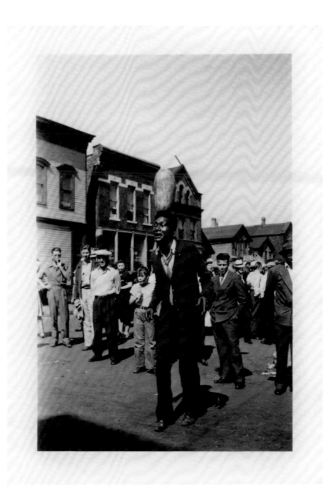

1930S—CHICAGO, ILLINOIS

LOOK NATURAL: A ONE-MAN PARADE HEADS DOWN MAXWELL STREET, CHICAGO'S LEGENDARY OPEN-AIR BAZAAR. A SHOPPER COULD BUY—AND FIND—JUST ABOUT ANYTHING ON MAXWELL, CONSIDERED THE NATION'S MOST EXTENSIVE "GHETTO MARKET" FOR ALMOST A CENTURY. IT WAS THE FIRST STOP FOR MANY CHICAGO NEWCOMERS, INCLUDING AFRICAN AMERICANS FROM THE SOUTH WHO BROUGHT MISSISSIPPI DELTA BLUES WITH THEM. THE MARKET WAS DEMOLISHED IN THE 1990S BY THE UNIVERSITY OF ILLINOIS AT CHICAGO, WHICH SOUGHT TO EXPAND.

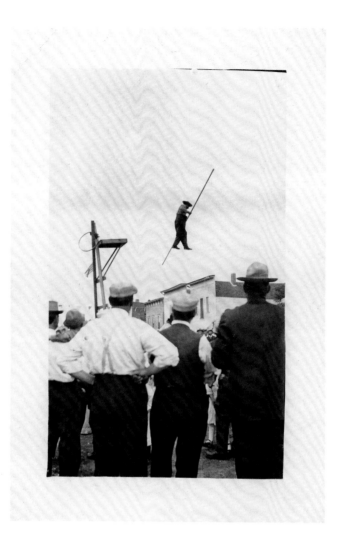

1920S
County Fair

WITH GREAT EASE: A TIGHTROPE WALKER TIPTOES ABOVE A CROWD AT A COUNTY FAIR—THE FESTIVAL THAT MARKS SUMMER IN SMALL TOWN AMERICA WITH MERRY-GO-ROUNDS, PIE-EATING CONTESTS, AND LIVESTOCK SHOWS.

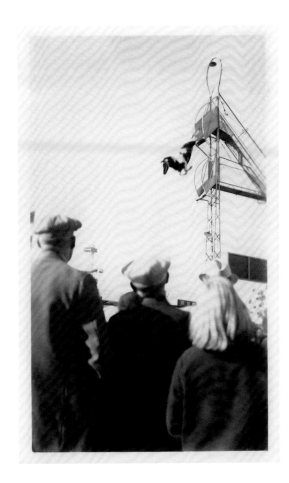

ABOUT 1930

MAKING A SPLASH: FOR ABOUT HALF A CENTURY, HIGH-DIVING HORSES WERE POPULAR ENTERTAINMENT AT COUNTY FAIRS, CARNIVALS, AND TOURIST DESTINATIONS. AT THE STEEL PIER IN ATLANTIC CITY, NEW JERSEY, HORSES AND THEIR WOMEN RIDERS JUMPED OFF A PLATFORM INTO A TWELVE-FOOT WATER TANK. ONLY ONE SERIOUS INJURY WAS EVER REPORTED THERE DESPITE DECADES OF CRITICISM FROM ANIMAL RIGHTS GROUPS. THE STEEL PIER HORSE ACT WAS FOLLOWED BY DIVING JACKASSES.

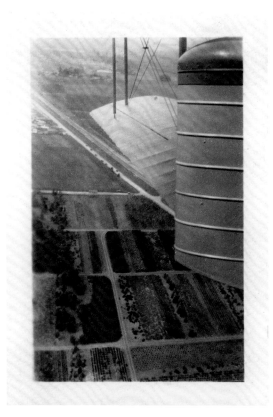

1930
Taken from the plane—Curtiss-Condor. July 4th, 1930

A WALK IN THE AIR: THE CONDOR, A TWIN-ENGINE BIPLANE, WAS ONE OF THE NATION'S EARLY COMMERCIAL PASSENGER PLANES. IT WAS ALSO THE STAR OF MANY STATE AND COUNTY FAIRS, TAKING OFF FROM GRASS STRIPS FOR $2 A RIDE. FOR MANY, IT WAS THEIR FIRST FLIGHT.

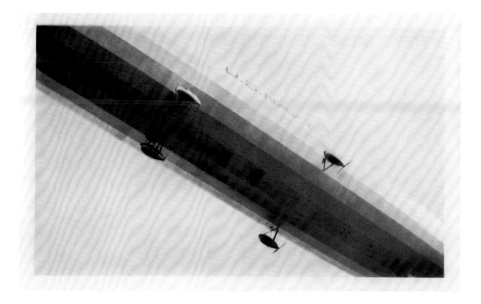

ABOUT 1925
THE SILVER WHALE: THE NAVY DIRIGIBLE SHENANDOAH, CALLED THE "STAUNCHEST AIRCRAFT EVER BUILT," WAS RIPPED APART IN A THUNDERSTORM ABOVE SOUTHEASTERN OHIO IN 1925. FOURTEEN OF ITS 43 CREW MEMBERS WERE KILLED. THE OTHERS WERE SAVED BY FARMER ERNEST NICHOLS, WHO GRABBED A CABLE DROPPED FROM THE SHENANDOAH AS THE WOUNDED AIRSHIP DRIFTED TOWARD HIS HOUSE. NICHOLS WRAPPED THE CABLE AROUND A FENCE POST AND THEN AROUND A TREE STUMP, BUT THOSE DIDN'T HOLD. FINALLY, HE WRAPPED IT AROUND A TREE. CREW MEMBERS CLIMBED DOWN, AND USED NICHOLS' SHOTGUN TO PUNCTURE THE HELIUM-FILLED AIRSHIP.

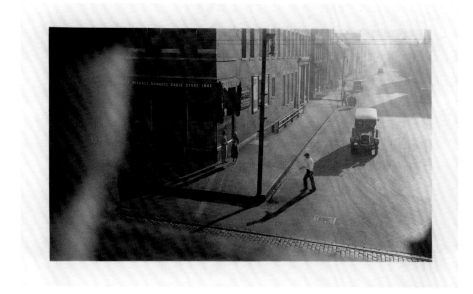

SEPTEMBER 18, 1933—CHICAGO, ILLINOIS

Taken from Mrs. Douse's window looking east on 19th Street. The camera caught two fems on the corner.

A LAST LOOK: FROM A PHOTO ALBUM COMPILED BY AN IOWA MAN NAMED MATT. THIS PICTURE WAS TAKEN ON THE FINAL DAY OF HIS TEN-DAY TRIP TO SEE THE CENTURY OF PROGRESS EXHIBITION—AND CHICAGO FEMALES.

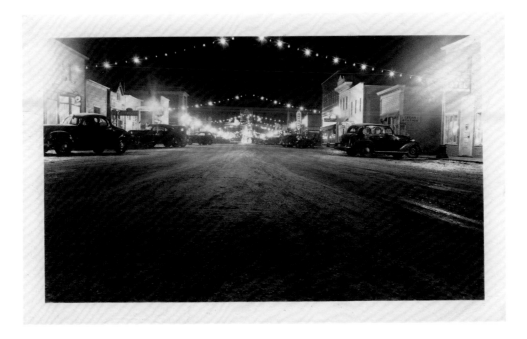

ABOUT 1940—CROSBY, NORTH DAKOTA

Street scene. Fairly sharp. Bowling alley is even on this picture. If you look very close you will see the court house and the camels on top.

CHRISTMAS DREAMING: FOR GENERATIONS, THE CITY OF CROSBY WAS KNOWN FOR ITS HOLIDAY LIGHTS DRAPED ACROSS MAIN STREET. BUT THE LIGHTS WERE EVENTUALLY REMOVED. THEY INTERFERED WITH HUGE SEMIS RUMBLING THROUGH TOWN.

'Of Course I Love Her'

Until the age of snapshots, most photographs of couples were stiff and posed. Much of the woodenness was due to the limits of the photographic process at the time—long exposures required subjects to remain still for up to sixty seconds. But the results were also due to the culture of the day. Public displays of affection were condoned. And marriage was considered the only sexual relationship worth fixing an image.

That changed when Americans started taking their own pictures. Now, for the first time, photos were taken of couples in action—flirting, smiling, roughhousing, even seducing. People could be surprisingly bold and passionate in front of a camera. Snapshooters made their own rules, governed only by their personal standards and by what they were willing to let the local photofinisher see. Surprisingly, photographers (and their subjects) were willing to show a lot. Their photos were filled with affection and sexual power. They show America, even Puritanical America, in a clench.

Since the introduction of the snapshot camera, photos have been used to start and keep relationships. As early as 1889, the *New York Times* wrote about the "young knights of the camera" off on photographic hunts. "They are inoffensive in appearance, but well armed with dangerous weapons to those who may fall in their way," the newspaper reported. "Of course, pretty girls are their natural prey."

Fast forward more than a century, and Americans swap digital photos online with would-be paramours. "Your photo gets mine," is the harkening call. The most elucidating of these photographs are still the snapshots. The real thing, devoid of studio tricks.

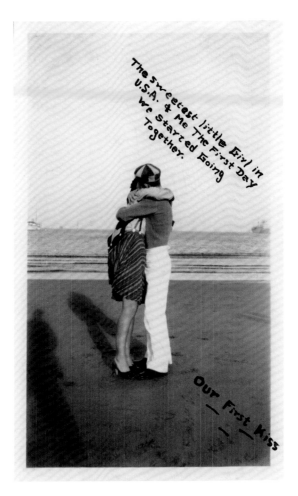

The Sweetest little Girl in U.S.A. & Me The First Day We Started Going Together.

Our First Kiss __/__/__

1930S
AIN'T MISBEHAVIN': FOR THE FIRST TIME, ENTIRE RELATIONSHIPS—FROM THE FIRST DATE THROUGH THE BREAKUP—COULD BE DOCUMENTED ON FILM.

ABOUT 1930
CREAM OF THE CROP: "EVERY GIRL HAS IN MIND AN IDEAL MAN," WROTE FEMINIST MARGARET SANGER. "THIS IDEA BEGINS TO FORM SOMETIME IN EARLY ADOLESCENT AGE. HE IS USUALLY DISTINCT IN HER MIND AS TO HIS PHYSICAL QUALITIES, SUCH AS DARK OR LIGHT HAIR, OR BROWN OR BLUE EYES. HE IS ALWAYS A CERTAIN PHYSICAL TYPE, AND OFTEN REMAINS AN IDEAL TO HER THROUGH LIFE."

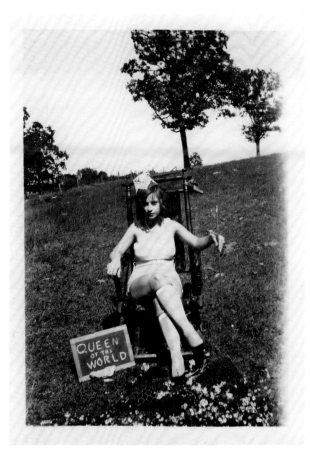

ABOUT 1930
DON'T YOU WISH: "FROM THE PRAIRIE VILLAGE TO THE CITY TENEMENT, THE AMERICAN WOMAN SEES IN MARRIAGE THE FULFILLMENT OF HER HEART'S DESIRE,—TO BE QUEEN, TO RULE AND NOT WORK." SO WROTE NOVELIST ROBERT HERRICK.

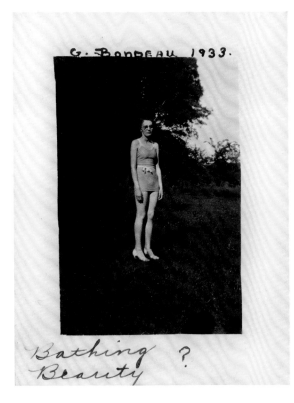

G. BONDEAU 1933.

Bathing Beauty ?

1933
NOTHING TO WRITE HOME ABOUT: BY THE 1930S, THE POPULARITY OF THE FLAT-CHESTED FLAPPER STYLE WAS WANING. "SPRING STYLES SAY 'CURVES'!" PROCLAIMED *VOGUE* MAGAZINE IN 1932. BRAS WERE REENGINEERED TO EMPHASIZE "THE UPLIFT BUST."

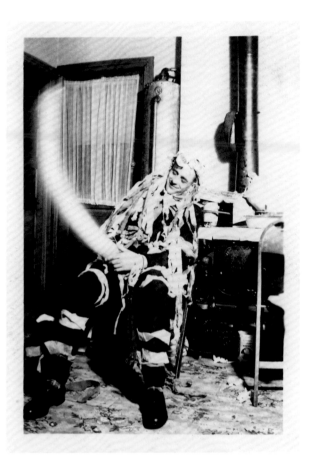

1930S
GIRLS DON'T CROWD: "SEX IS NO LONGER NEWS," WROTE *FORTUNE* MAGAZINE IN 1936. "AND THE FACT THAT IT IS NO LONGER NEWS
IS NEWS."

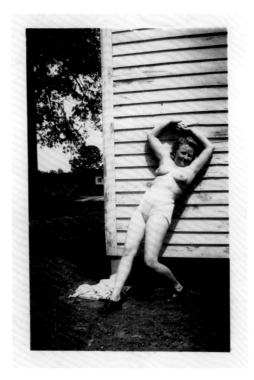

ABOUT 1930
PASSED BY THE CENSOR: THE EASTMAN KODAK COMPANY REFUSED TO RETURN PHOTOS OF NUDES SENT FOR DEVELOPING BECAUSE COMPANY OFFICIALS FEARED BEING CHARGED WITH VIOLATING POST OFFICE RULES ON OBSCENE MATERIAL.

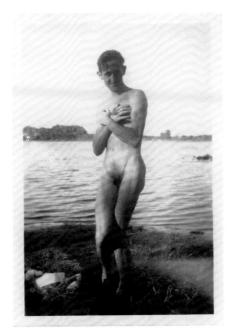

ABOUT 1930
IN THE BUFF: ONE MAN REPORTEDLY CHALLENGED KODAK'S POLICY BY SENDING NUDE NEGATIVES ALONG WITH CARRIER PIGEONS TO THE ROCHESTER, NEW YORK, PLANT. "IF YOU HAVE A DROP OF SPORTING BLOOD, YOU'LL SEND MY PICTURES BACK," HE REPORTEDLY WROTE. THE PIGEONS RETURNED—BUT WITHOUT THE PICTURES.

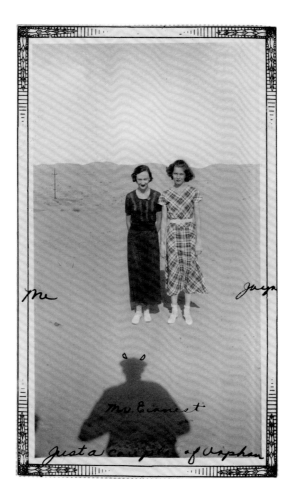

1934
THE DEVIL MADE ME DO IT: MYSTERIOUS MARKINGS OF A JOURNEY TO CALIFORNIA.

1938—NEAR PRESTONBURG, KENTUCKY
JUST A NUT FROM THE OLD FAMILY TREE: FLEMING TACKETT, 34, POSES WITH HIS TEN-YEAR-OLD BRIDE, ROSIE COLUMBUS. THEIR 1938 MARRIAGE CAUSED A FUROR, ACCORDING TO THE *CLARINDA HERALD JOURNAL*, BECAUSE ROSIE'S MOTHER LISTED THE BRIDE'S AGE AS FIFTEEN WHEN APPLYING FOR A LICENSE. A DEAL WAS SUSPECTED. "THE GIRL'S PARENTS HAVE BEEN LIVING IN A CAVE AND NOW WILL HAVE A MOUNTAIN CABIN TO MOVE INTO," THE PAPER REPORTED.

1934—CHICAGO, ILLINOIS
WHO'S SORRY NOW?: HOWARD BECK AND WIFE NELLIE GIFFNEY. BECK, A BOOTLEGGER, WAS SENTENCED TO LIFE IN PRISON IN 1928 FOR TAKING PART IN A GUN BATTLE THAT KILLED A POLICEMAN. FIVE YEARS LATER, HE ESCAPED FROM A FLORIDA CHAIN GANG, AND MADE IT TO CHICAGO, WHERE HE MET AND MARRIED NELLIE. BECK WAS RETURNED TO FLORIDA, BUT ESCAPED AGAIN IN 1948. TWO YEARS LATER HE WAS ARRESTED IN CHICAGO AGAIN. NO REPORT ON NELLIE. THIS IS A SNAPSHOT TAKEN OF TWO FRAMED PHOTOBOOTH IMAGES.

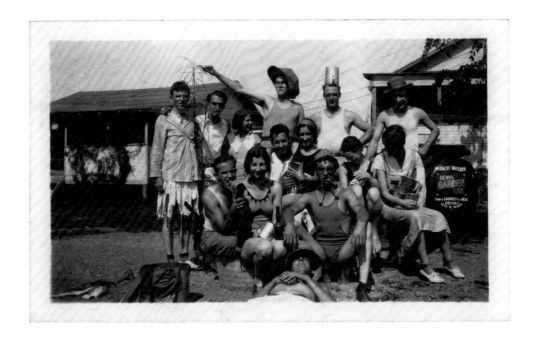

ABOUT 1935—DAYTON, OHIO
JUST A BIT WARM BY THE LOOK OF THINGS: HARD TIMES DIDN'T PUT AN END TO MALE-FEMALE HIJINKS. HERR'S GARDEN INN, A
NEIGHBORHOOD RESTAURANT NORTH OF DOWNTOWN DAYTON, DID NOT SURVIVE THE DEPRESSION. NOT SURE IF ANY OF THESE
RELATIONSHIPS DID EITHER.

ABOUT 1930
SHE HITCHED HER: TWO WOMEN, DRESSED AS MAN AND WIFE, KISS ON THEIR "HONEYMOON." SNAPSHOTS OF CROSSDRESSING
WEDDINGS WERE COMMON IN THE FIRST HALF OF THE TWENTIETH CENTURY.

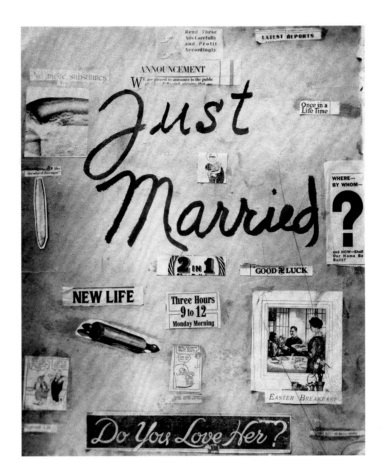

1919—MITCHELL, SOUTH DAKOTA

This is what I found on shop door Monday morning April 21, 1919. Yours truly Berger Jelmeland. P.S. Of course I love her!

Rooftop Rag

Rooftops were a perfect place from which to photograph the city. In 1930, almost every large city in America boasted at least one public observation deck; New York had nearly a dozen. Atop tall buildings, nightclub owners opened rooftop gardens and theater groups mounted shows. The Pierre Hotel advertised itself as having "the highest and coolest hotel roof in Manhattan."

But the most memorable roofs were atop walkup apartments because they offered a convenient oasis in the heart of the city. Before air conditioning, Americans needed creativity to keep cool, particularly if they lived in urban areas. To escape the summer heat, residents would open fire hydrants, visit the beach, or withdraw to the country. But there was another option—refuge on the roof.

Life in the summer, especially in New York City, revolved around the top floor. That's where people hung their clothes to dry, grew tomatoes, escaped from their families, or just contemplated life beneath the clouds. During the worst heat waves, renters headed upstairs for a good night's sleep. On cooler days, a roof might belong to you.

For a photographer, rooftops were charged spaces—somewhat public, somewhat private. A place where women showed their underwear, and where men posed in drag. Take a look: the roof was where you could reveal yourself. Where no one could see you. But us.

1926—CHICAGO, ILLINOIS
ALLEY-OOP: ACROBATS AND FLAGPOLE SITTERS CALLED ATTENTION TO CITY HEIGHTS DURING THE LATE 1920S.

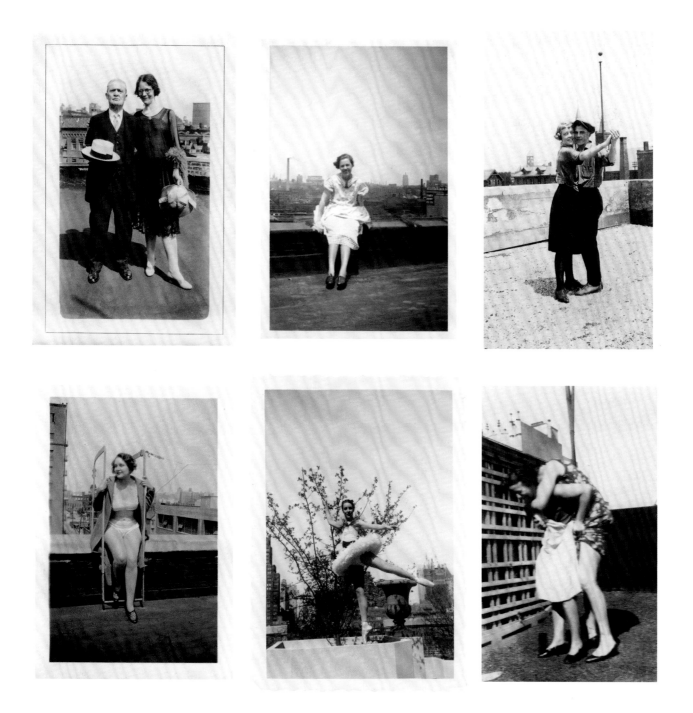

1930S
THE HIGH LIFE: AMERICA'S BUILDINGS GAINED AN EXTRA FLOOR DURING WARM-WEATHER MONTHS. THE VIEWS WERE TERRIFIC.

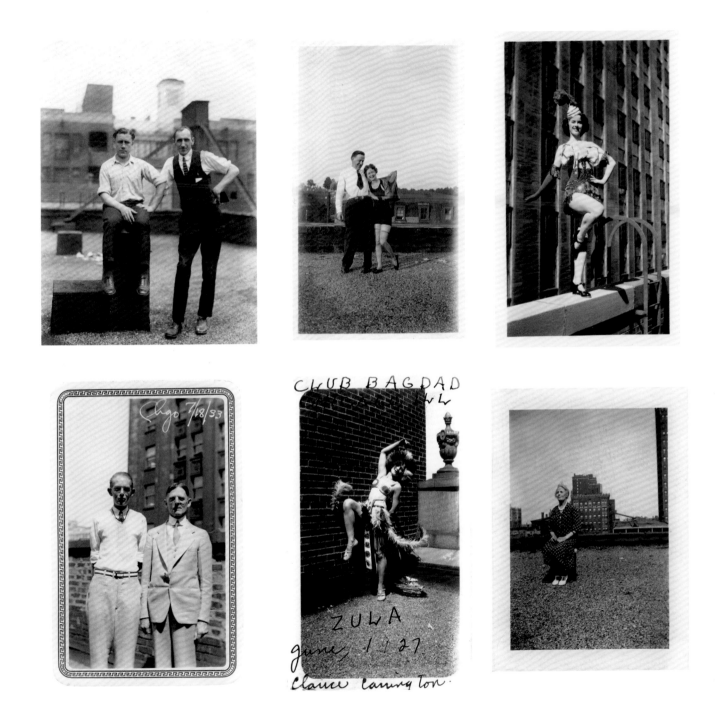

TOP ROW, RIGHT: *See what I mean about the costumes. One glove is red—the other chartreuse.*

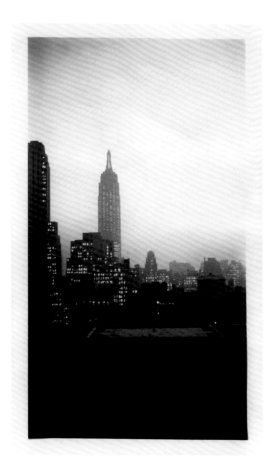

AROUND 1930

ON TOP OF THE WORLD: LEFT: NEW YORK'S 102-STORY EMPIRE STATE BUILDING, WHICH OPENED IN 1931, IS ONCE AGAIN THE CITY'S TALLEST. RIGHT: THE SIX-STORY CHATTANOOGA TIMES BUILDING IN TENNESSEE WAS THE CITY'S TALLEST WHEN OPENED IN 1892. FROM THAT ROOF, A GIANT LIGHT PROCLAIMED THE END OF WORLD WAR I. THE SKYSCRAPER IS NOW KNOWN AS THE DOME BUILDING.

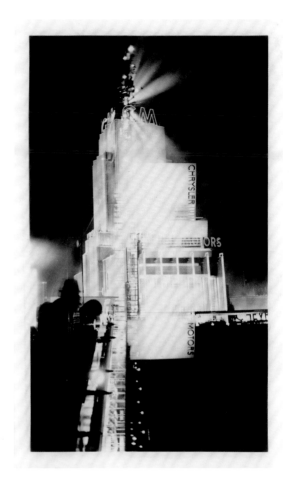

1930S

WHAT A WORLD!: ABOVE: THE GLASS CENTER AT THE NEW YORK WORLD'S FAIR IN 1939 AND 1940. RIGHT: THE GENERAL MOTORS AND CHRYSLER BUILDINGS AT THE 1933 CENTURY OF PROGRESS IN CHICAGO. BOTH PHOTOGRAPHS ARE DOUBLE EXPOSURES.

'The Little Boy In The Sailor's Cap'

Until Pearl Harbor, most Americans were reluctant about fighting another world war. But the deadly, ninety-minute Japanese attack on Battleship Row in 1941 galvanized the country. War was declared on Japan the next day and on Germany four days later.

Taking photographs during World War II—on the front lines and on the home front—was difficult and dangerous. Army regulations once again prohibited fighting men from using cameras, but again the rules were ignored. Soldiers sent hundreds of thousands of war photos back home. In America, film for snapshots was scarce but available.

After Pearl Harbor, Americans were warned that cameras posed a security risk. In 1942, President Roosevelt signed a bill that prohibited the photography of waterfronts, bridges, railroads, defense works, industrial plants, and other high-security spots. "The wise amateur will not then carry a camera in such area," editors of *American Photography* cautioned. Later that year, one New England manufacturing town banned photography within its city limits. "Such restrictions are foolish and unnecessary," the editors wrote. Foreign aliens—particularly Germans, Japanese, and Italians living in the United States—had it worse. They were prohibited from even possessing a camera, and at least a few were arrested.

World War II became a geography lesson for most Americans. Guadalcanal, Normandy, Saipan, Leyte, Luzon, and Iwo Jima became familiar names until 1945, when allied bombers and troops forced Germany and Japan into submission. Upon their surrender, photo restrictions were immediately lifted.

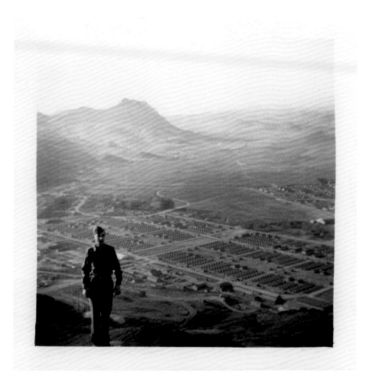

ABOUT 1940—CAMP SAN LUIS OBISPO, CALIFORNIA
I'M ON MY WAY: A SOLDIER STANDS ATOP A HILL OVERLOOKING THE NEW ARMY BASE OF CAMP SAN LUIS OBISPO IN SOUTHERN CALIFORNIA. THE UNITED STATES, A NATION OF IMMIGRANTS, WAS SPLIT ABOUT ENTERING WORLD WAR II AFTER JAPAN INVADED MANCHURIA AND CHINA, AND GERMANY INVADED POLAND. BUT THE NATION BEGAN MOBILIZING IN THE LATE 1930S.

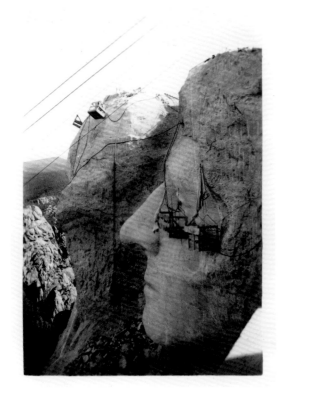
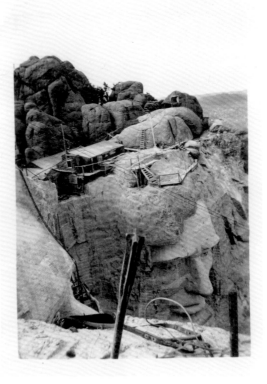

ABOUT 1935—NEAR KEYSTONE, SOUTH DAKOTA
AMERICA FIRST: AS ANOTHER WORLD WAR BECAME INCREASINGLY INEVITABLE, MANY FELT THE MOST PATRIOTIC RESPONSE WAS TO AVOID THE CONFLICT AND FOCUS ON AMERICA'S PRIORITES. TO CELEBRATE THE COUNTRY, SCULPTOR GUTZON BORGLUM AND 400 WORKERS SPENT THIRTEEN YEARS USING JACKHAMMERS AND DYNAMITE TO CARVE FOUR PRESIDENTS INTO MOUNT RUSHMORE. BORGLUM WAS ALSO SUPPOSED TO CARVE A 500-WORD HISTORY OF THE UNITED STATES WRITTEN BY CALVIN COOLIDGE, BUT THE FORMER PRESIDENT LATER BALKED WHEN THE SCULPTOR INSISTED ON EDITING HIS WORK.

ABOUT 1940—NEW YORK CITY, NEW YORK
OUR FAVORITE UNCLE: HEADING SOUTH ON CENTRAL PARK WEST, UNCLE SAM JOINED THE MACY'S THANKSGIVING DAY PARADE IN 1938. THE PARADE WAS NOT HELD DURING WORLD WAR II DUE TO THE ARMY'S NEED FOR RUBBER AND HELIUM.

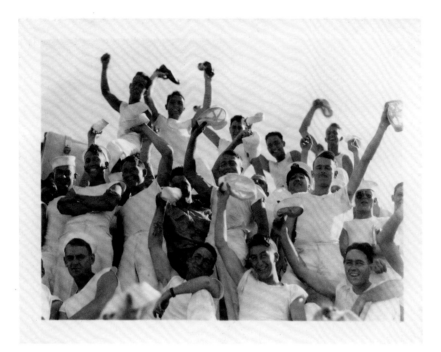

EARLY 1940S—PACIFIC OCEAN
U.S.S. California

THINK WHAT THIS MEANS: RELUCTANCE TO ENTER THE WAR ENDED ON DECEMBER 7, 1941, WITH JAPAN'S SURPRISE ATTACK ON PEARL HARBOR. THE U.S.S. CALIFORNIA, SEVERELY DAMAGED THAT DAY, WAS REFLOATED, REPAIRED, AND REBUILT. THE CALIFORNIA RETURNED TO THE PACIFIC, WHERE IT TOOK PART IN THE 1944 BATTLE OF SURIGAO STRAIT, THE LAST BIG-GUN BATTLE IN NAVAL HISTORY. IT IS UNCLEAR WHEN THIS PHOTO WAS TAKEN.

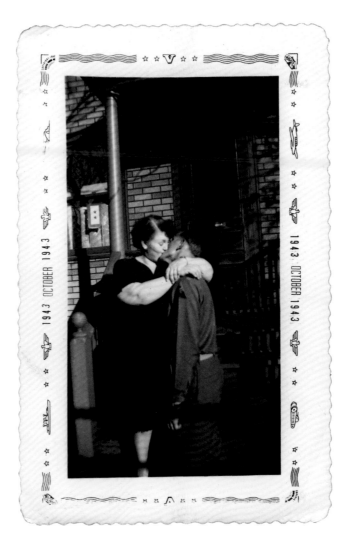

1943 · OCTOBER 1943

1943—CHICAGO, ILLINOIS

THE KISS THAT MADE ME CRY: THE DAY AFTER PEARL HARBOR, AMERICANS LINED UP AT RECRUITING CENTERS BEFORE THE DOORS OPENED. SO MANY MEN AND WOMEN WANTED TO JOIN THE COAST GUARD THAT IT SET UP A QUOTA SYSTEM. HERE A SOLDIER BIDS GOODBYE TO HIS MOTHER. THE TWO BLUE STARS IN HER WINDOW INDICATE SHE HAD TWO CHILDREN IN THE SERVICE.

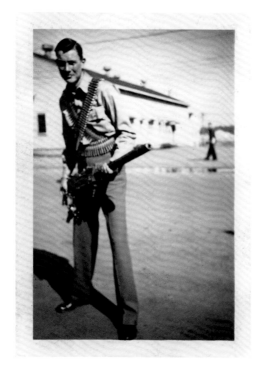

JUNE 20, 1943
To slap the Jap in his hole. For a sergeant named Dercole.

1940S
Not very good but I imagine you see a difference in this than the little boy in the sailor's cap.

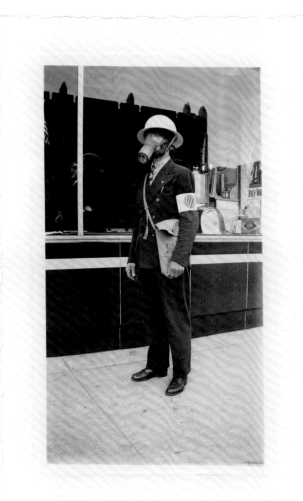

EARLY 1940S
DICKY-BIRD: AN AIR RAID WARDEN MODELS THE FASHION OF THE DAY. THE OFFICE OF CIVILIAN DEFENSE TRAINED ABOUT 10 MILLION VOLUNTEERS TO PROVIDE FIRST AID, FIGHT FIRES, AND DECONTAMINATE THE AREA AFTER A CHEMICAL WEAPON ATTACK. THE WARDEN IS WEARING HIS INSIGNIA UPSIDE DOWN.

1940S

KEEP 'EM MOVING: THE WOMEN FLYERS OF AMERICA, FOUNDED IN 1940, FERRIED PLANES FROM FACTORIES TO AIR BASES, AND TRANSFERRED THEM FROM BASE TO BASE DURING WORLD WAR II. WOMEN WERE GIVEN UNIFORMS, WINGS, AND INSIGNIAS, BUT THEY NEVER RECEIVED OFFICER COMMISSIONS.

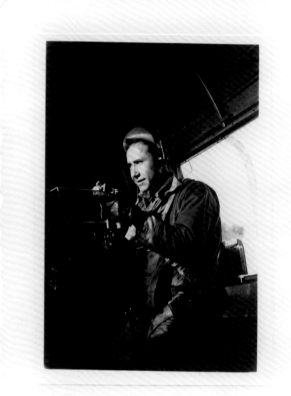

EARLY 1940S—EUROPEAN THEATER
LEFT: *Pilot Lt. Metzroth*
RIGHT: *Jim Richardson, armorer in nose turret*

RAISING H _ _ _ : IN 1944, LAWRENCE F. METZROTH WAS COPILOTING A BOMBER OVER BERLIN WITH ANOTHER CREW WHEN THE PLANE DEVELOPED ENGINE TROUBLE AND DITCHED INTO THE NORTH SEA. METZROTH AND MATES WERE PLUCKED FROM THE WATER BY A NAZI SEAPLANE AND HELD AS PRISONERS FOR THE DURATION OF THE WAR. DECADES LATER, HIS WIFE JUNE SAID: "HE ALWAYS SAID THE BRITISH DIDN'T PICK HIM UP BECAUSE THEY WERE OUT TO TEA."

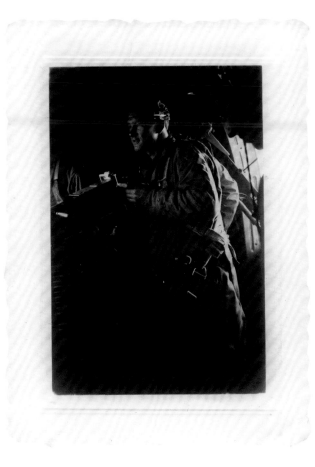

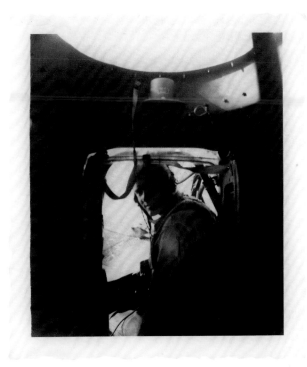

LEFT: *Smitty firing left gun, assistant radio operator*
RIGHT: *John B. Tomoney, engineer*

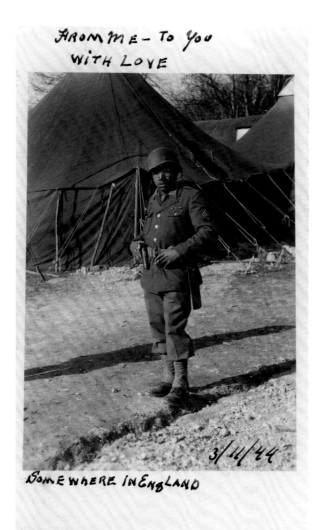

FROM ME— TO YOU WITH LOVE

3/11/44

SOMEWHERE IN ENGLAND

1944—ENGLAND

HELLO FROM HERE, HOW IS IT THERE?: G.I.S OVERSEAS WERE NOT ALLOWED TO DIVULGE LOCATIONS OR STRATEGIC INFORMATION IN LETTERS SENT BACK HOME. MILITARY CENSORS CHECKED MOST ALL CORRESPONDENCE. IN ADDITION, MORE THAN 10,000 CIVILIAN CENSORS WERE HIRED DURING THE WAR TO READ AND CHECK ALL DOMESTIC MAIL.

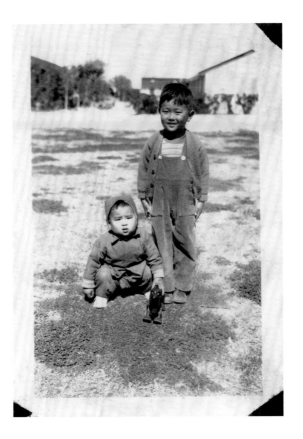

1945—GILA RIVER INDIAN RESERVATION, ARIZONA
Last picture in camp. April 1945

FAR FROM HOME: BILL SUGANO AND HIS BABY BROTHER, FRANK, PLAY AT THE GILA RIVER RELOCATION CENTER, SOUTH OF PHOENIX. FRANK WAS BORN IN THE CAMP IN 1943. THEY WERE AMONG 110,000 PEOPLE OF JAPANESE ANCESTRY SENT TO TEN PERMANENT CAMPS STARTING IN 1942. PARENTS LEO AND KIMIKO SUGANO, BOTH BORN IN CALIFORNIA, OPERATED A FLOWER FARM, WHICH THEY WERE FORCED TO SELL DAYS AFTER THE GOVERNMENT ORDERED ALL JAPANESE LIVING IN THE WEST TO REPORT TO ASSEMBLY AND RELOCATION CENTERS. THEIR PARENTS NEVER RETURNED TO CALIFORNIA.

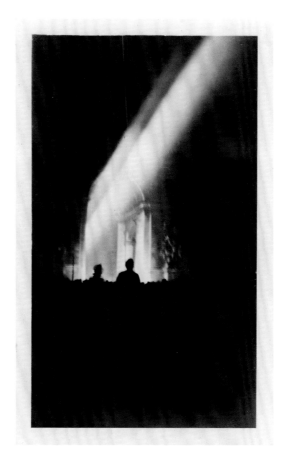

MAY 1945—PARIS, FRANCE
KILROY WAS HERE: VICTORY IN EUROPE DAY, CELEBRATED IN PARIS. WROTE SOLDIER JOHN HORSLEY: "WHEN DARKNESS APPROACHED THE WHOLE UNIVERSE LOOKED ALIGHT WITH THE ARC DE TRIOMPHE STANDING OUT AS A PILLAR OF FIRE."

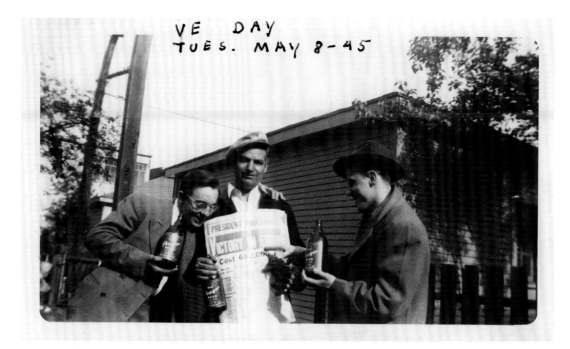

VE DAY
TUES. MAY 8-45

MAY 8, 1945—CHICAGO, ILLINOIS
IT'S (FINALLY) OVER: CHICAGOANS BEGAN CELEBRATING GERMANY'S UNCONDITIONAL SURRENDER ON APRIL 28, BUT FIRST REPORTS PROVED FALSE. TEN DAYS LATER, THE CELEBRATION WAS FOR REAL. ONE WEALTHY MAN DOWNTOWN ASKED PASSING SAILORS AND SOLDIERS TO JOIN HIM FOR LUNCH. "I JUST WANTED TO SAY THANKS," HE SAID.

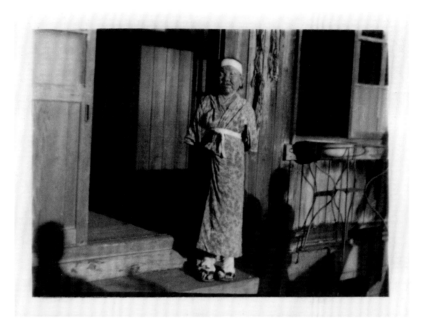

ABOUT 1945—HIROSHIMA OR NAGASAKI, JAPAN
REMAINS OF THE WAR: A VICTIM OF AN ATOMIC BOMB BLAST. "LITTLE BOY," DROPPED ON HIROSHIMA, AND "FAT MAN," DROPPED ON NAGASAKI THREE DAYS LATER, KILLED ABOUT 220,000 PEOPLE. "IF I HAD KNOWN THAT THE GERMANS WOULD NOT SUCCEED IN CONSTRUCTING THE ATOM BOMB, I WOULD NEVER HAVE LIFTED A FINGER," SAID ALBERT EINSTEIN AFTER THE WAR. IT WAS SEVERAL WEEKS BEFORE AMERICAN TROOPS ENTERED THE TWO CITIES.

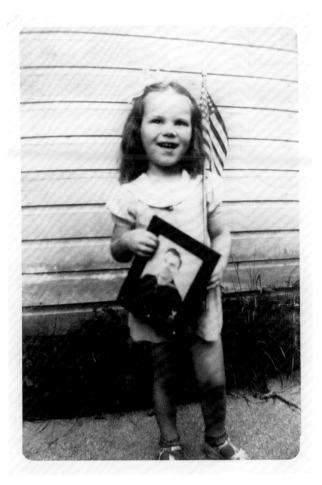

AUGUST 14, 1945

O, HOW SHE LOVES HER DADDY: VICTORY OVER JAPAN DAY WAS CELEBRATED AFTER EMPEROR HIROHITO ANNOUNCED JAPAN'S UNCONDITIONAL ACCEPTANCE OF SURRENDER TERMS. IN A RADIO BROADCAST TO JAPANESE CITIZENS, HIROHITO DECLARED THAT ALLIED POWERS POSSESSED "A NEW AND TERRIBLE WEAPON" THAT DEMANDED AN END TO THE WAR. "THE FREQUENT KILLING OF INNOCENTS AND THE EFFECT OF DESTITUTION IT ENTAILS ARE INCALCULABLE," HE SAID.

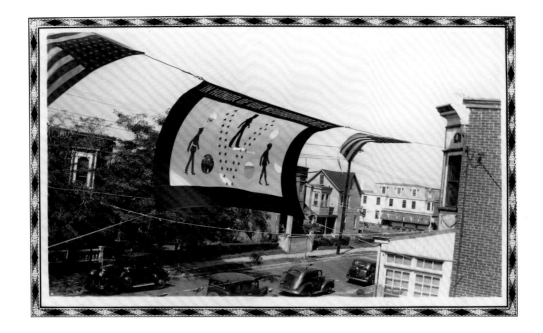

1940s
THERE'S A STAR-SPANGLED BANNER WAVING SOMEWHERE: MORE THAN 400,000 AMERICANS DIED FIGHTING OVERSEAS IN THE WAR, A SMALL PART OF THE 25 MILLION MILITARY CASUALTIES AND 47 MILLION CIVILIAN CASUALTIES. MOST G.I.S RETURNED HOME BY EARLY 1946.

EARLY 1940S—PACIFIC THEATER

I guess I just never give up hoping that each of you will feel the enthusiasm that I feel and make every effort possible to be at the reunions.

COMING HOME: PORTRAITS OF TROOPS FROM THE 813TH ENGINEER BATTALION (AVIATION) WERE MOUNTED IN A WOODEN DISPLAY AND LIT TO MARK THEIR ATTENDANCE AT REUNIONS FOR DECADES AFTER THE WAR. BOMBED AND STRAFED BY JAPANESE PLANES, THE BATTALION BUILT A KEY FIGHTER STRIP ON ATTU ISLAND THAT WAS USED TO RAID JAPAN.

'Your Eyes Are Windows'

After the war, Lieutenant Lawrence Metzroth returned to Springfield, Illinois, and opened Larry's North Side Flower Shop. Little Bill and Frank Sugano moved with their family to Chicago. World War II ended suddenly, but not for everybody. Some veterans returned to broken homes and an uncertain future. Working women, once told it was patriotic to fill the ranks of factory workers, were now told it was unpatriotic to keep their jobs. And African Americans, who fought for freedom, came back to bigotry.

As it has since the Oregon Trail, the open road called Americans after the war. With gas and tire rationing over, it lured people West for adventure and a new life. Journeys down America's highways have become faster and easier since pioneer days, but no less meaningful as a rite of passage.

The proof is in our photo albums—thousands of snapshots of roadside attractions, state-line welcome signs, and other points of interest. Jack Kerouac was able to record his *On The Road* memories on a 120-foot written scroll. Most travelers prefer a roll of film.

But it's not just the road that we enshrine. Our cars hold a prominent place in many family albums. We photograph them washed and waxed in our driveways, and we use them as backdrops for family portraits. A new baby emerges from a '48 Buick. Many pages later, she stands prom-straight in front of a '65 Chevy. For many, our cars are our lifelines.

1940S
DON'T FENCE ME IN: "FOR ME THIS IS WHERE IT BEGINS," SAID MARLON BRANDO IN THE 1953 FILM *THE WILD ONE*, "RIGHT ON THIS ROAD."

ABOUT 1950

A LONG, DUSTY ROAD LEADING NOWHERE: ROUTE 66, JOHN STEINBECK'S "MOTHER ROAD" IN *GRAPES OF WRATH*, CONNECTED CHICAGO TO LOS ANGELES—AND HUNDREDS OF TOWNS IN BETWEEN—THROUGH A SWEEPING DIAGONAL ROUTE. IT SYMBOLIZED FREEDOM AND OPPORTUNITY AFTER THE WAR. THESE PHOTOS WERE TAKEN ON A WESTERN TRIP ON AND AROUND ROUTE 66.

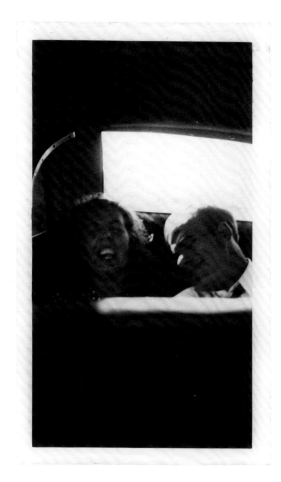

ABOUT 1950
BACK-SEAT DRIVERS: CARS OFFERED MORE THAN TRANSPORTATION. THEY OFFERED A PLACE TO BE ALONE AND A PLACE FOR PARTNERS.

ABOUT 1950
A SIGHT TO BEHOLD: "YOUR EYES ARE WINDOWS," DECLARED A DODGE ADVERTISEMENT IN 1949. "JUST FRAME IT IN THE PICTURE WINDOW OF YOUR EYE. DRIVE IT FOR THE PLEASANT WORLD IT OFFERS."

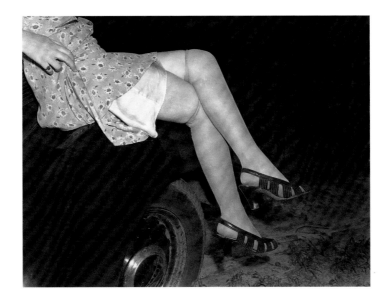

ABOUT 1950
WOW . . . LOOK AT THEM LEGS: "WE ALL HAVE HEARD ABOUT THE HYDRAMATIC CAR," SANG BLUESMAN JOE HILL LOUIS IN 1953. "TAKE YOU SO FAST AND CARRY YOU SO FAR. BUT WHEN IT COMES TO WOMEN I BET YOU DON'T KNOW. (I GOT A) HYDRAMATIC WOMAN AND SHE SURE AIN'T SLOW."

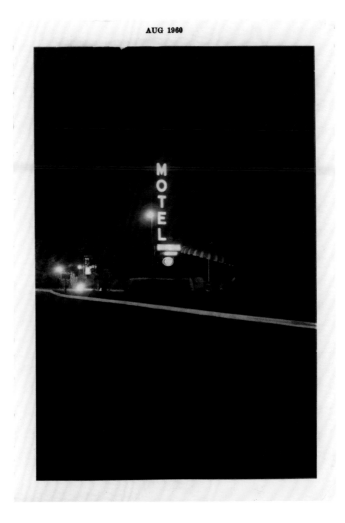

AUG 1960

AUGUST 1960
NO VACANCY: THE OPEN ROAD WAS SOON NOT SO OPEN. AUTO CAMPS, ROPED OFF AREAS WHERE DRIVERS COULD PARK AND SLEEP, WERE SOON REPLACED BY ROADSIDE COTTAGES, WHICH OFFERED BEDS. THE COTTAGES GAVE WAY TO MOTOR COURTS AND MOTELS. ROAD TRIPS NOW BECKONED ENTIRE FAMILIES.

1950S—SALT LAKE CITY, UTAH

LONESOME ME: "I WAS FAR AWAY FROM HOME," JACK KEROUAC WROTE IN *ON THE ROAD*, "HAUNTED AND TIRED WITH TRAVEL, IN A CHEAP HOTEL ROOM I'D NEVER SEEN, HEARING THE HISS OF STEAM OUTSIDE, AND THE CREAK OF THE OLD WOOD OF THE HOTEL, AND FOOTSTEPS UPSTAIRS, AND ALL THE SAD SOUNDS, AND I LOOKED AT THE CRACKED HIGH CEILING AND REALLY DIDN'T KNOW WHO I WAS FOR ABOUT FIFTEEN STRANGE SECONDS."

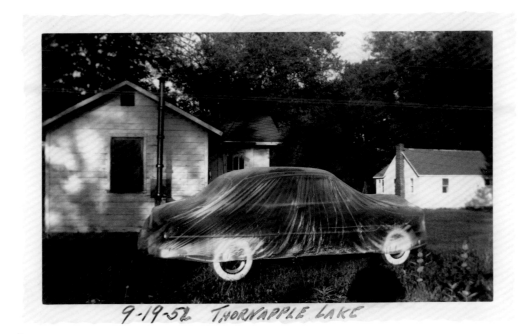

9-19-52 THORNAPPLE LAKE

1952—THORNAPPLE LAKE, MICHIGAN
MAGIC HOUR: THE END OF THE ROAD. SOMETIMES IT WAS HOME. SOMETIMES IT WAS FAR FROM HOME.

'Dede At Bat'

"They give us those nice bright colors," sang Paul Simon. "They give us the greens of summers. Makes you think all the world's a sunny day."

He was singing about Kodachrome, the slide film that has defined our recent past with a luxuriant color palette as brilliant as our imagination.

Kodachrome was America's first full-color film, and it has remained our most enduring and endearing. It was invented by professional musicians Leopold Mannes and Leopold Godowski Jr., high school friends known as Man and God who spent fourteen years perfecting the complex chemistry behind the film. Kodachrome, with three layers of emulsion, was introduced in 1935 as movie film. The next year, it was adapted for 35mm still cameras, which were popular at the time.

Walker Evans, at first, called color film "vulgar." Robert Frank declared that "black and white are the colors of photography." But amateurs and professionals disregarded the opinions of these photo icons. With fine grain and incredible sharpness, Kodachrome gave us a chance to record the world in super-realistic color and detail. After World War II, Americans embraced color like they embraced Brownies, and Kodachrome transformed the face of photography as much as any single invention. Color now symbolizes America of the 1950s. The country fell in love with Kodachromes—and the slideshow was born.

1955-1957
HERE'S WHERE I BELONG: SLIDE FILM SENT PHOTOGRAPHERS ON A NEW MISSION: TO CAPTURE COLOR FOR COLOR'S SAKE. MANY CHOSE SIMPLE DOMESTIC SCENES.

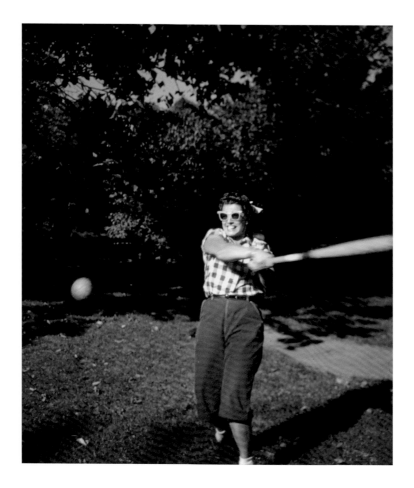

1955-1957—CHICAGO, ILLINOIS
Dede at bat

A BIG HIT: A KODACHROME TAKEN WITH A THREE-DIMENSIONAL STEREO REALIST CAMERA. MANUFACTURED FROM 1947 TO 1972, THE STEREO REALIST RODE THE WAVE OF 3-D POPULARITY IN THE EARLY 1950S AND SOLD WELL, DESPITE ITS INITIAL $160 PRICE TAG.

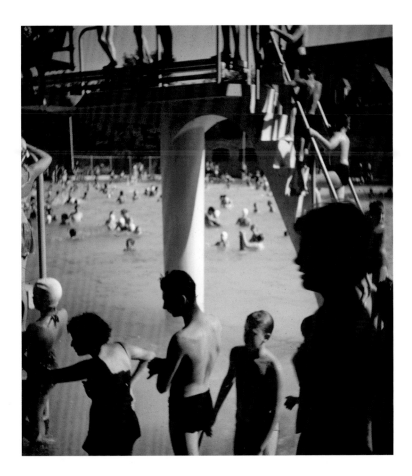

1959—CHICAGO, ILLINOIS
A SUMMER PLACE: ANOTHER FRAME FROM A TWO-FRAME STEREO REALIST. THE CAMERA AND ITS IMITATORS FELL OUT OF FAVOR IN THE MID-1950S AS THE 3-D CRAZE IN PHOTOGRAPHY AND MOTION PICTURES SUBSIDED.

1962—DAVENPORT, CALIFORNIA
IN A FAMILY WAY: THE FIRST-GENERATION ANDRADE FAMILY GATHERS IN THE BACKYARD OF THEIR CALIFORNIA HOME AFTER A FAMILY BAPTISM. THEY ARE (FROM LEFT) ALBERTO, LUPE, BABY DAVID, AND PETE. THE PHOTOS WERE TAKEN BY THEIR UNCLE, RUBEN Q. GOMEZ, WHO LOVED SEEING COLOR IMAGES OF HIS FAMILY PROJECTED ON THE BIG SCREEN.

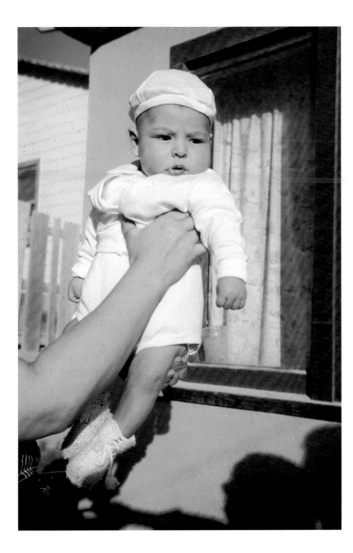

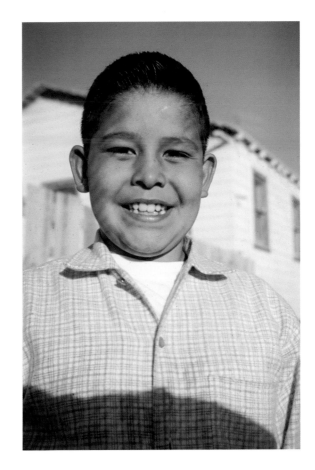

1957
WHAT THE CAMERA EYE SAW: FOUR OF ABOUT FIFTY OUT-OF-FOCUS SLIDES TAKEN BY AN ANONYMOUS MIDWESTERN FAMILY. THE IMAGES, FOUND DECADES LATER STILL IN THEIR CAROUSEL, SHOW THEIR HOME LIVES AND A TRIP TO NIAGARA FALLS. IT MUST HAVE MADE FOR AN UNUSUAL SLIDESHOW.

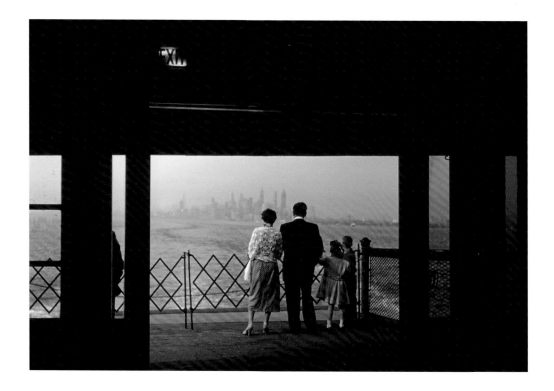

1955 TO 1957—NEW YORK CITY, NEW YORK
DO YOU RECOGNIZE MY BACK?: APPROACHING LOWER MANHATTAN ON THE STATEN ISLAND FERRY, A POPULAR PHOTO PERCH FOR TOURISTS.
THE CITY CELEBRATED ITS 100TH YEAR OPERATING THE FERRY IN 2005. ALMOST 20 MILLION PEOPLE RIDE THE FERRIES ANNUALLY.

1958—RENO, NEVADA
ON THE STREAMLINER: A PULLMAN PORTER GREETS PASSENGERS ABOARD UNION PACIFIC'S CITY OF SAN FRANCISCO PASSENGER TRAIN NEAR RENO, NEVADA. IN 1925, PULLMAN PORTERS ORGANIZED AMERICA'S FIRST PREDOMINANTLY AFRICAN AMERICAN MAJOR LABOR UNION, THE BROTHERHOOD OF SLEEPING CAR PORTERS. AFTER RAIL TRAVEL DROPPED SHARPLY IN THE 1960S AND UNION MEMBERSHIP PLUMMETED, THE PORTERS MERGED WITH A LARGER TRANSPORTATION UNION.

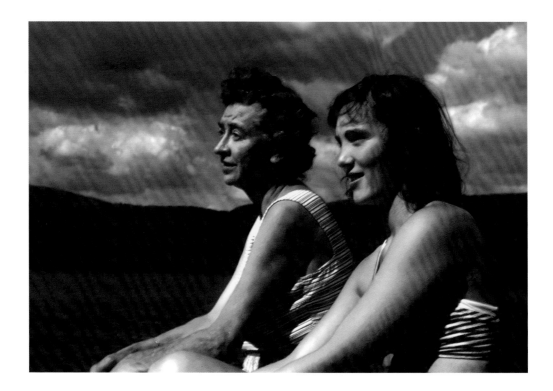

ABOUT 1945—NEAR WELLS, VERMONT
A PERFECT DAY: LUCY POTTER BROWN AND A YOUNG FRIEND SIT ON A PIER AT HER SUMMER HOME ON LAKE ST. CATHERINE. BROWN, A HOMEMAKER, KEPT BRIEF NOTES ABOUT HER LIFE THAT INCLUDED WHEN GUESTS WENT SWIMMING (CALLED "LAKE DUNKINGS"), THE APPEARANCE OF CANADA GEESE, STEAK DINNERS ON THE PORCH, AND THE PURCHASE OF SUCH THINGS AS THE FAMILY'S FIRST ELECTRIC BLANKETS AND COLOR TV SET.

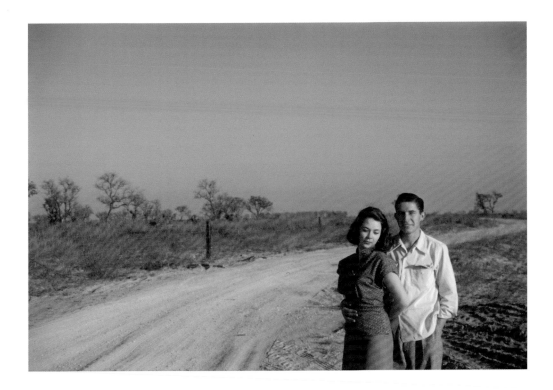

ABOUT 1950—FALFURRIAS, TEXAS
RIGHT OUT OF TENNESSEE WILLIAMS: DOXIE HUDSON WALKS ALONG A COUNTRY ROAD NEAR FALFURRIAS, TEXAS, WITH A LONG-LOST BEAU. MORE THAN A HALF-CENTURY LATER, DOXIE COULDN'T RECALL HIS NAME, BUT REMEMBERED THAT HE WANTED TO MARRY HER. HE WAS ONE OF MANY.

'Dean In Hula Hoop'

One of the ways that Americans took advantage of their postwar prosperity was by purchasing a camera. By 1955, two out of every three families owned at least one. Men did the purchasing, but women took the pictures. "The greatest total of snapshooting is done right at home," reported the *Saturday Evening Post* in 1954, "and the busiest photographer in the country is the American housewife. She is a perpetual picture taker and she is profligate of film."

Most women did not fit the mold of serious amateurs. They did not pay much attention to filters, f-stops, light meters, or film speed. They generally didn't join photo clubs or take photo vacations. But women were the official photographers of the baby boom. Their number one subject? Children.

No other generation was so well documented. Every aspect of growing up was photographed—from the daydreaming days of summer to first dances. And with more kids, family photographs seemed never-ending.

Fifties parents were determined to give their kids a childhood free of hardships, and they were proud to document the new opportunities they were providing. Taking pictures became an essential American value, like caring for lawns and buying new cars.

It took determination for women to gain control of the camera. "Next time you shop," advised Dorothy Field of *Popular Photography* in 1956, "pass up the steak and buy hamburger or decide against the stunning hat you saw. With the money you save approach the nearest photographic dealer and ask the clerk for a sturdy, simple, inexpensive camera." They did just that.

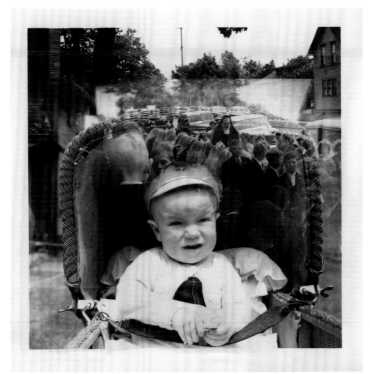

1950S
THE WHOLE WORLD . . . IN HIS EYES: DOUBLE EXPOSURES, LIKE THIS ONE, WERE OFTEN MADE BY MISTAKE—THE RESULT OF A PHOTOGRAPHER FORGETTING TO ADVANCE FILM. MANY PHOTOFINISHERS REFUSED TO PRINT THEM. WARNED ONE, IN WRITING: "THEY WILL NOT MAKE GOOD PICTURES."

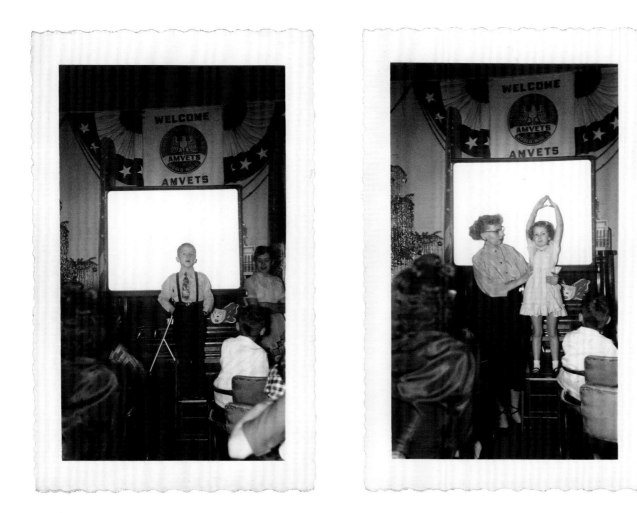

1950S

SCREEN GEMS: CHILDREN BECAME THE FOCUS OF THE NUCLEAR FAMILY FOLLOWING WORLD WAR II. THESE CHILDREN TOOK PART IN A HOLIDAY TALENT SHOW SPONSORED BY THE AMERICAN VETERANS OF WORLD WAR II, WHICH WAS FOUNDED IN 1944. THE SERVICE ORGANIZATION IS NOW CALLED THE AMERICAN VETERANS OF FOREIGN WARS.

1950S

HAPPY TRAILS: THE NATION'S COWBOY CRAZE, WHICH BEGAN WITH THE SINGING COWBOYS OF THE 1920S, REACHED ITS PEAK THIRTY YEARS LATER WITH COWBOY HATS, BOOTS, LUNCH BOXES, EVEN DUDE RANCH VACATIONS. WESTERNS RULED TELEVISION AND FILMS AS CHARACTERS SUCH AS ROY ROGERS, DAVY CROCKETT, AND THE MARBORO MAN BECAME NATIONAL FOLK HEROES.

1961—MONTCLAIR, CALIFORNIA
Dean Hartman and Bimbo Demay at Ricky Awston's 7th birthday party 1961, Montclair, Calif. Dean in hula hoop

ANYONE CAN PLAY: MORE THAN 100 MILLION HULA HOOPS WERE SOLD DURING THE FIRST YEAR AFTER THEIR INTRODUCTION IN 1958. GUITARIST MICKEY WAY, OF THE BAND MY CHEMICAL ROMANCE, WROTE: "THERE'S LESS VIOLENCE IN THE WORLD WHEN PEOPLE ARE USING HULA HOOPS."

ABOUT 1960
A KODAK MOMENT: "ALL PHOTOS ARE ACCURATE," WROTE RICHARD AVEDON. BUT HE WARNED: "NONE OF THEM IS THE TRUTH."

ABOUT 1960
QUITE A CATCH: BY THE 1950S, THE STAID, FORMAL FAMILY PORTRAIT WAS A THING OF THE PAST.

LATE 1950S—CALIFORNIA

Conn Chaudoin, Ken Scholz '57, '58. Kite at rt. broke 25# test line. Conn died in Vietnam—1970.

WE REMEMBER: FIRST LIEUTENANT ROBERT CONN CHAUDOIN, FROM SAN MARINO, CALIFORNIA, WAS KILLED IN VIETNAM IN 1971 AT AGE 24. HIS TOUR BEGAN ON JANUARY 29. HE WAS KILLED ON MARCH 27.

1950S

BODY BLOW: THE IRON LUNG WAS BOTH A GODSEND AND A PRISON FOR POLIO SUFFERERS. THE RESPIRATOR STIMULATED WEAK CHEST MUSCLES IN A SEALED CHAMBER. IT WAS USED PRIMARILY IN HOSPITALS AND HOMES FROM THE 1920S THROUGH THE MID-1950S, WHEN A CURE FOR POLIO WAS DISCOVERED. BY THE YEAR 2000, ONLY A FEW DOZEN POLIO SURVIVORS STILL NEEDED THE IRON LUNG.

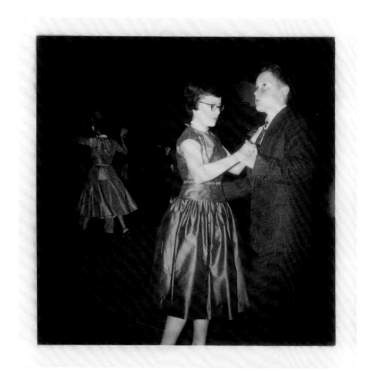

1950s

THINK HE'S SORT OF SHY: THE TERM "TEENAGER," COINED IN THE FORTIES, DEFINED THE SEMI-INDEPENDENT, POST-WAR GENERATION OF YOUNG ADULTS WHO CHOSE THEIR OWN CLOTHES, LISTENED TO THEIR OWN MUSIC, AND BORROWED THE CAR. PRE-TEENS AND TEENAGERS WERE A HARDY NEW BREED, CAUGHT BETWEEN CHILDHOOD AND ADULTHOOD.

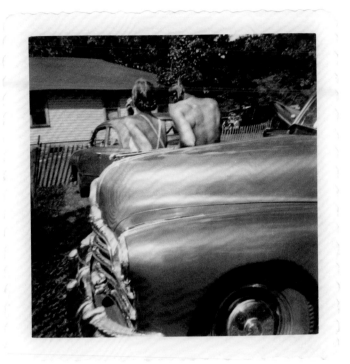

1950S
ALMOST GROWN: TEENAGERS JOINED THEIR PARENTS IN THE CAMERA CRAZE. "THEY ARE SHOOTING FLASH PICTURES OF EACH OTHER ALL THE TIME," WROTE THE *SATURDAY EVENING POST* IN 1954. "AT THE MILK BAR, AT THE BASKETBALL GAMES; THEY EVEN PACK CAMERAS TO DANCES NOW."

The Gathering Storm

Behind the hula hoops and TV dinners that characterized the 1950s was a nation coming to grips with complex issues.

A few months before the decade began, the Soviet Union tested its first atomic bomb. The news, so shocking, was withheld from the American public for weeks. The United States responded in 1950 by manufacturing the hydrogen bomb, estimated to be a thousand times more powerful than the Hiroshima bomb. The Doomsday Clock moved closer to midnight.

The Cold War, declared two years after the end of World War II, intensified during the 1950s into a hot war in Korea and hot words all over the world. "We will bury you," Soviet Premier Nikita Khrushchev reportedly told Western diplomats in 1956. Those words were followed the next year with nuclear-armed U.S. intercontinental ballistic missiles and the Soviet Sputnik satellite. Meanwhile, at home, the Supreme Court's 1954 decision to integrate public schools sparked a civil rights movement that continues to this day.

For the first time, America's challenges and anxieties could be seen clearly in family photos. They show the Jim Crow South, the Cold War and Korean War, and the suburban subdivisions that replaced old neighborhoods. Were photographers becoming more aware, or was the malaise oozing across America difficult to avoid?

Probably both.

ABOUT 1960—NEW MEXICO
LAST PICTURE ON THE ROLL: A LOOK BACK AT A THREATENING SKY. THE FINS ARE A '56 CADILLAC.

1950S

WHAT WE SAW: WHITES IN SOUTHERN AND BORDER STATES DEPENDED ON LOCAL AND STATE LAWS TO MAINTAIN THE SEPARATION OF RACES. JIM CROW LAWS BARRED AFRICAN AMERICANS FROM SHARING SUCH THINGS AS DRINKING FOUNTAINS AND WASHROOMS, BUSES AND STREETCARS, PARKS AND BEACHES, EVEN LIBRARY BOOKS.

1950S

BACK OF THE BUS: DEMONSTRATIONS HASTENED THE PASSAGE OF FEDERAL LAWS IN THE 1960S DESIGNED TO END LEGALIZED SEGREGATION. "BEING A NEGRO IN AMERICA MEANS TRYING TO SMILE WHEN YOU WANT TO CRY," WROTE MARTIN LUTHER KING JR.

APR • 60

APRIL 1960

AMEN, AH-MAN: AMERICA'S CHURCHES EXPERIENCED A REVIVAL AFTER WORLD WAR II. EVANGELISTS EMBARKED ON MAJOR CRUSADES, AND CHURCH MEMBERSHIP INCREASED FROM 70 MILLION TO 100 MILLION IN THE DECADE FOLLOWING THE WAR. CONFIDENCE IN RELIGION INCREASED, TOO. A 1957 POLL SHOWED THAT FOUR OUT OF EVERY FIVE AMERICANS BELIEVED THAT RELIGION COULD ANSWER MOST OR ALL MODERN PROBLEMS.

MEXICAN STREET IN LOS ANGELES — OLVERA STREET

1950S—LOS ANGELES, CALIFORNIA

BIENVENIDOS: LOS ANGELES' OLVERA STREET, REVIVED IN 1930 AS A MEXICAN PLAZA MARKET, WAS SPRUCED UP IN THE LATE 1950S AS AN URBAN RENEWAL PROJECT. "ALTHOUGH SOME HISTORY HAS VANISHED IN THE PROCESS, MOST VISITORS ARE PLEASED BY THE NUMEROUS PARKING LOTS IN THE VICINITY," WROTE THOMAS MCDONALD, OF THE *NEW YORK TIMES*.

1953—SOUTH KOREA

This is one of the mosquitos out here. That is my hand. You can see how big they are.

HOW'S THAT FOR A CLOSE-UP: KOREA WAS THE WAR THAT WAS NEVER DECLARED. IN 1950, THE UNITED STATES SENT TROOPS INTO SOUTH KOREA TO BEAT BACK A SURPRISE ATTACK BY THE NORTH KOREAN ARMY. THE CONFLICT—WHICH ATTRACTED CHINA, THE SOVIET UNION, AND SEVEN OTHER NATIONS—ENDED THREE YEARS LATER IN A STALEMATE AND CEASEFIRE. NO PEACE TREATY WAS EVER SIGNED BETWEEN THE TWO KOREAS.

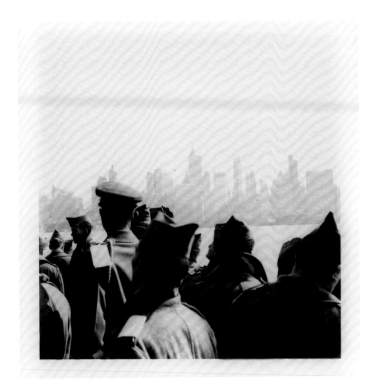

1950S—NEW YORK CITY, NEW YORK
ON A SLOW BOAT: STOPPING THE SPREAD OF COMMUNISM WORLDWIDE BECAME A FULL-TIME JOB OF THE DEFENSE DEPARTMENT AFTER
THE WAR. THOUSANDS OF TROOPS WERE DEPLOYED TO EUROPE TO FACE OFF WITH THE SOVIET UNION AND WARSAW PACT ALLIES.

ABOUT 1960

INTO THE WILD BLUE: THE B-52 STRATOFORTRESS, ACTIVE SINCE 1955, WAS BUILT TO CARRY NUCLEAR BOMBS AND CONVENTIONAL WEAPONS. IT SERVED AS A SYMBOL OF DETERRENCE DURING THE COLD WAR YEARS.

ABOUT 1960
TOO WELL SHELTERED TO BE SEEN PLAINLY: "WE HAVE ONE FOOT IN GENESIS AND THE OTHER IN APOCALYPSE, AND ANNIHILATION IS ALWAYS ONE IMMEDIATE OPTION," WROTE ACTIVIST MICHAEL HARRINGTON. ON THE SCREEN IS PHYSICIST EDWARD TELLER, WHO WAS KNOWN AS THE FATHER OF THE HYDROGEN BOMB.

1955
This is our house 8-'55.

HERE'S THE PLACE: THE BABY BOOM, COMBINED WITH HIGHWAYS AND HOMEOWNERS TAX BREAKS, CREATED A HOUSING SURGE AFTER THE WAR. LONG ISLAND'S LEVITTOWN LED THE WAY, WITH TWO-BEDROOM HOMES COMPLETE WITH A GENERAL ELECTRIC STOVE AND REFRIGERATOR, STAINLESS STEEL SINKS AND CABINETS—ALL FOR $7,990 WITH $90 DOWN. "NO MAN WHO OWNS HIS OWN HOUSE AND LOT CAN BE A COMMUNIST," SAID BUILDER WILLIAM LEVITT IN 1950. "HE HAS TOO MUCH TO DO."

ABOUT 1960
NOTHING THAT MOVES MISSES BEING SEEN: ANYONE COULD PURCHASE GUNS AT HARDWARE STORES, ARMY SURPLUS STORES, GAS STATIONS, OR VIA MAIL-ORDER CATALOGUES UNTIL THE 1960S. NO WAITING, NO BACKGROUND CHECK, NO FINGERPRINTS. BUT THE ASSASSINATIONS OF JOHN F. KENNEDY, MARTIN LUTHER KING JR., AND ROBERT F. KENNEDY TIGHTENED GUN CONTROL LAWS BY 1968. EVEN TOY GUNS WERE REMOVED FROM THE SEARS CHRISTMAS CATALOG THAT YEAR.

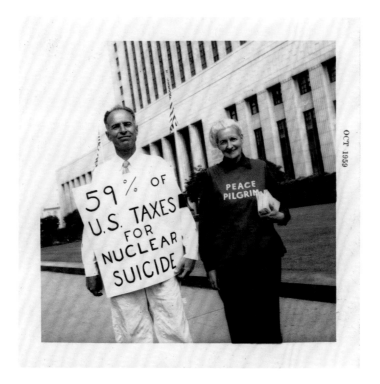

APRIL 15, 1959—LOS ANGELES, CALIFORNIA

WANTED—A GOOD WOMAN: MILDRED RYDER, KNOWN ONLY AS PEACE PILGRIM, DEMONSTRATES AT THE LOS ANGELES DISTRICT COURTHOUSE. STARTING IN 1953, AT AGE 44, SHE VOWED TO KEEP WALKING UNTIL THE WORLD LEARNED TO LIVE IN PEACE. SHE LOGGED 25,000 MILES BY 1964, WHEN SHE GAVE UP COUNTING BUT NOT WALKING. "A PILGRIM'S JOB IS TO ROUSE PEOPLE FROM THEIR APATHY AND MAKE THEM THINK," SHE TOLD A CHURCH GROUP IN 1981 ON HER SEVENTH CROSS-COUNTRY WALK. A MONTH LATER, SHE DIED IN AN AUTO ACCIDENT ON HER WAY TO A SPEECH IN INDIANA.

AUGUST 1, 1958—PACIFIC OCEAN
FROM HERE TO ETERNITY: A HIGH-ALTITUDE HYDROGEN BOMB, KNOWN AS TEAK, IS DETONATED FORTY-EIGHT MILES ABOVE THE PACIFIC. THE BLAST, CLEARLY VISIBLE IN HONOLULU 700 MILES TO THE NORTHEAST, STARTLED RESIDENTS WHO WERE NOT WARNED. HAWAIIANS PLANNED BEACH PICNICS SO THEY WOULD NOT MISS THE NEXT TESTS—WHICH WERE ANNOUNCED IN ADVANCE. ATMOSPHERIC TESTS BY THE UNITED STATES AND SOVIET UNION ENDED IN 1962, BEFORE THE 1963 PARTIAL TEST BAN TREATY.

'He Very Well Could Be Alive'

During the 1960s, the snapshot camera became a key recorder of political life. Demonstrators took cameras on civil rights marches, hippies took them to Woodstock, and soldiers took them to Vietnam. Instamatics, Polaroids, and 35mm cameras offered an alternative view to the America portrayed in *Life* and *Look* magazines. As in past eras, snapshots offered a more personal view of America.

The issues of the 1950s played out in the sixties. The white-only drinking fountain transformed into marches and riots. The cold war of words turned into a war in Indochina, and the rifle aimed out a window turned into assassins' guns. Ironically, one of the most significant photographs of the decade was a snapshot—a backyard photo of Lee Harvey Oswald taken by wife Marina with a cheap, plastic camera months before the 1963 assassination of President John F. Kennedy. The photo depicts Oswald holding a gun similar to the one that killed Kennedy. Oswald called the photo a fake after the shooting. But the picture, which withstood decades of examination, links Oswald to the assassination, and hints at the man behind the shooting.

Of course all snapshots, like all photographs, are fakes. They miniaturize the world, place images in a false frame, and turn three-dimensional reality into two-dimensional representations. But they are valued for their truth-telling ability. "All of us live, without realizing it, in a world of which we are aware primarily because of photography," wrote John A. Kouwenhoven in his 1982 book *Half a Truth Is Better Than None*. "And the overwhelming majority of the photographs to which we owe our awareness are snapshots.

"We live," he concluded, "quite literally, in a snapshot world."

MID-1960S
UP YOURS: INSTANT CAMERAS MADE IT POSSIBLE FOR PHOTOGRAPHERS TO BE MORE FREE WITH THEIR SUBJECTS, AND SUITED THE ERA. THE POLAROID, WHICH PRODUCED A PRINT A MINUTE, WAS INTRODUCED IN 1947. COLOR FILM WAS ADDED IN 1963.

[FOLLOWING PAGES]
NOVEMBER 22-25, 1963—ELGIN, ILLINOIS
WE ALL WATCHED: THE DAYS FOLLOWING THE ASSASSINATION OF PRESIDENT JOHN F. KENNEDY AS SEEN ON TV.

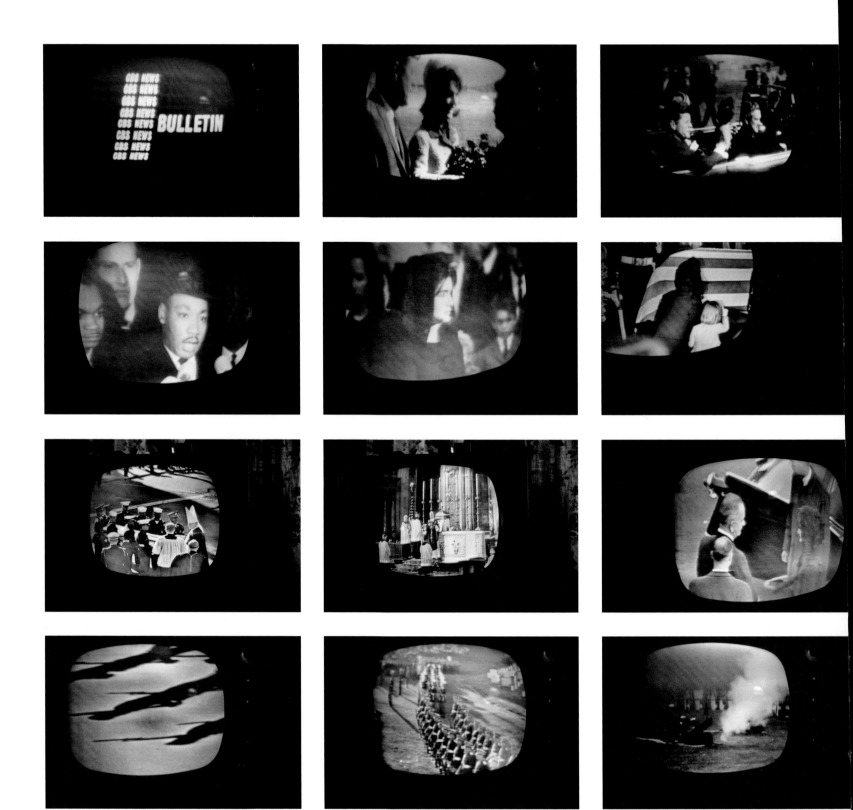

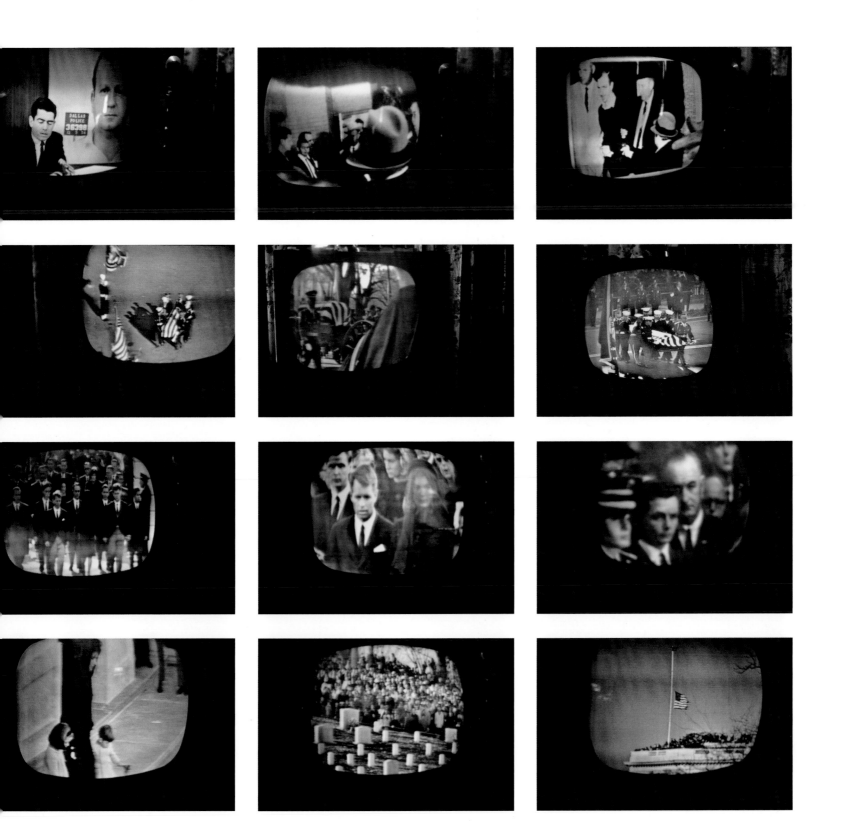

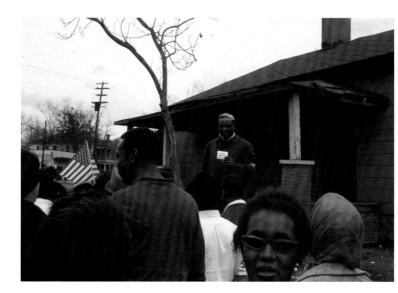

MARCH 24-25, 1965—MONTGOMERY, ALABAMA
EVERY WAVE CARRYING A MESSAGE: THE FINAL DAY OF THE FIFTY-FOUR-MILE SELMA-TO-MONTGOMERY CIVIL RIGHTS MARCH, WHICH STARTED ON "BLOODY SUNDAY" AND CONCLUDED WITH SPEECH BY DR. MARTIN LUTHER KING JR. AT THE ALABAMA STATE CAPITOL. GOVERNOR GEORGE WALLACE, WHO OPPOSED THE MARCH, GAVE FEMALE STATE EMPLOYEES A LEGAL HOLIDAY TO PROTECT THEM AS 25,000 DEMONSTRATORS APPROACHED MONTGOMERY.

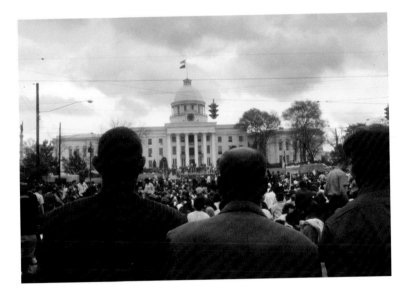

THESE PHOTOS WERE TAKEN BY CHARLES RATHBONE, 23, WHO FLEW FROM HIS COLLEGE IN SYRACUSE, NEW YORK, THAT MORNING IN A PLANE RENTED BY LOCAL MINISTERS. "I DIDN'T TELL MY PARENTS THAT I WAS GOING," RATHBONE RECALLED. "WE WERE KEPT IN NARROW RANKS, AWAY FROM THE CURBS OF THE STREET," RATHBONE SAID OF THE GRAY AND RAINY DAY. AT THE MONTGOMERY AIRPORT, HE SHOOK THE HAND OF REVEREND KING. "IT WAS THE ONLY DAY I WITNESSED HISTORY ON A NATIONAL SCALE," RATHBONE SAID.

NOVEMBER 1968—POWAY, CALIFORNIA
LITTLE HIPPIE GIRL: "I WAS JUST ABOUT TO TURN SIXTEEN, AND THE EVENTS OF THE FOLLOWING YEAR CHANGED MY LIFE FOREVER,"
WROTE SUZI BONDS. "THIS PHOTO, MORE THAN ANY OTHER, TAKES ME BACK TO THOSE LAST DAYS OF MY INNOCENCE."

OCTOBER 10, 1968—SAN FRANCISCO, CALIFORNIA
OUT OF SIGHT: A MAN KNOWN AS "CRAZY MITCH" PRACTICES BEFORE ATTENDING A JIMI HENDRIX CONCERT AT THE WINTERLAND. "MITCH USED TO PLAY THE GUITAR AS I DROVE MY PICKUP ALL THE WAY ON OUR FREQUENT TRIPS BETWEEN LOS ANGELES AND SAN FRANCISCO," RECALLED K.C. WINSTEAD, WHO TOOK THE PHOTO. HE LOST TRACK OF MITCH DECADES AGO.

1968—PHULOC, NORTHWEST OF DANANG IN SOUTH VIETNAM
GIVE A DAMN: A FRIGHTENED WOMAN IS APPREHENDED FOLLOWING A SEARCH-AND-DESTROY MISSION. "IT WAS UNUSUAL TO FIND YOUNG MEN OR WOMEN IN THE VILLAGES. GENERALLY, ALL WE WOULD FIND WERE VERY OLD MEN AND WOMEN AND CHILDREN," SAID MARINE RALPH VIZZARI, WHO TOOK HUNDREDS OF PHOTOS WITH AN INSTAMATIC CAMERA DURING HIS THIRTEEN-MONTH TOUR OF DUTY. THIS WOMAN WAS QUESTIONED AND RELEASED.

MARCH 1968—WEST OF DANANG, SOUTH VIETNAM

TO BE CONTINUED: U.S. MARINES LEAD A BLINDFOLDED VIETCONG OFFICER TO HEADQUARTERS. THE PRISONER, WHO CARRIED A RUSSIAN-MADE AK-47 ASSAULT RIFLE, HAD TRIED TO ESCAPE IN A RICE PADDY. "THERE WAS A BIG ARGUMENT WHETHER TO BRING THIS GUY BACK FOR INTERROGATION OR GET RID OF HIM," RECALLED VIZZARI, WHO HAD JUST ARRIVED IN VIETNAM WHEN HE TOOK THE PICTURE. BRINGING A CAPTIVE TO BASE CAMP OFTEN MEANT THAT TWO MARINE ESCORTS WOULD BE UNAVAILABLE TO THE REST OF THE SQUAD FOR MUCH OF A DAY. BECAUSE OF THE ADDED RISK, SOME PRISONERS WERE SHOT ON THE SPOT, HE SAID. "THIS WAS NOT NECESSARILY A COMMON PRACTICE OR AN EVERYDAY OCCURRENCE, BUT IT INDEED DID HAPPEN IN CERTAIN CIRCUMSTANCES," VIZZARI SAID. THIS PRISONER WAS TAKEN TO HEADQUARTERS. "HE VERY WELL COULD BE ALIVE TODAY."

AUGUST 15-18, 1969—BETHEL, NEW YORK
MIND BLOWING: MEMORIES OF A WET WEEKEND AT THE WOODSTOCK MUSIC AND ART FAIR. THESE PHOTOS WERE TAKEN BY JAMES BRESLIN OF HIS 18-YEAR-OLD GIRLFRIEND, LINDA GOLDBLATT. THEY WERE BOSTON COLLEGE STUDENTS WHO WERE DRIVEN TO WOODSTOCK IN A FRIEND'S VOLKSWAGEN BUS. LINDA REMEMBERS THE DAISIES DROPPED FROM A HELICOPTER, THE MUD THAT FELT LIKE "WARM SLUSH," SMOKING POT, MOUNDS OF GARBAGE, LONG LINES FOR THE BATHROOM, AND THE MUSIC. "I DON'T REMEMBER ANYONE NAKED," SHE SAID. "WE MUST HAVE BEEN IN THE WRONG AREA."

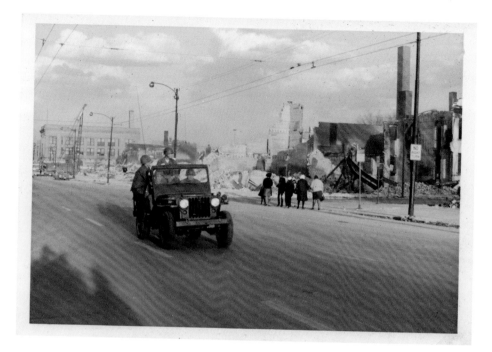

APRIL 1968—CHICAGO, ILLINOIS

GOT NOWHERE TO RUN: SOLDIERS PATROL THE DEVASTATED STREETS OF CHICAGO FOLLOWING THE 1968 RACE RIOTS THAT BROKE OUT AFTER THE ASSASSINATION OF MARTIN LUTHER KING JR. SOME 6,000 NATIONAL GUARDSMEN AND 5,000 SOLDIERS WERE CALLED TO HELP POLICE CURTAIL THE VIOLENCE. RIOTS ALSO BROKE OUT IN DOZENS OF OTHER AMERICAN CITIES. WARNED LANGSTON HUGHES, IN A 1940S POEM: "NEGROES, SWEET AND DOCILE, MEEK, HUMBLE, AND KIND: BEWARE THE DAY THEY CHANGE THEIR MIND!"

NOVEMBER 2, 1970—RIVERSIDE, CALIFORNIA
President Nixon 11-2-70

NIXON'S THE ONE: SEVENTY YEARS AFTER THEODORE ROOSEVELT'S TRIP TO MUNCIE, INDIANA, RICHARD M. NIXON ARRIVES BY HELICOPTER TO VISIT HIS 90-YEAR-OLD AUNT. THOUSANDS OF WELL-WISHERS GATHERED AT RIVERSIDE AIRPORT AS WORD SPREAD ABOUT THE TRIP. THE GOOD FEELING DID NOT LAST. FOLLOWING THE WATERGATE SCANDAL AND HIS RESIGNATION IN 1974, NIXON RETURNED TO CALIFORNIA IN DISGRACE.

The World We Know

Martin C. Johnson was more interested in the trip than the destination. For every photograph he took of the Grand Canyon or Mount Rushmore, he took more of the cafes where he ate and the motels where he stayed.

From the late 1950s through the early seventies, Martin and his wife Agnes crisscrossed the nation to celebrate their retirement and to celebrate America. Never timid about tripping the shutter of his 35mm cameras (a Pentax and Minolta), Martin took hundreds of color slides on each trip. His photos of service stations, waiting rooms, ballparks, and casinos are a singular slide show of America during the golden age of road trips.

Johnson was born in 1895, during the first decade of the snapshot, and spent most of his working life in the construction and printing industries. Martin was one of us, traversing a country that became more homogenous year after year. As he traveled, one place started to look like another, but that didn't stop him. Sometimes he pulled to the side of the road to take a picture; sometimes he didn't slow at all, but handed the camera to Agnes.

About 5,000 of their slides were recently purchased at a flea market. Johnson was far from alone in documenting this new America. Photography in the 1960s was routine and simple—and tourists often felt naked without a camera. Like many intrepid snapshooters, Martin loved photography because it gave him a reason to travel, a way to remember, and an excuse to buy more gadgets.

1960S TO EARLY 1970S
EVERYDAY PEOPLE: MARTIN JOHNSON'S LOVE SONG TO AMERICA.

'From Planet Earth'

He was a tourist, a quarter-million miles from home. And like any traveler, he wanted to bring home a special memory.

So Apollo 16 astronaut Charles M. Duke Jr. came up with a plan. Several months before his scheduled 1972 mission to the moon, Duke received permission from NASA to leave behind a family photograph. The picture—of Duke, wife Dorothy, and sons Charles III and Thomas—was taken by a friend in the Dukes' Houston, Texas, backyard several weeks before the April 16 liftoff.

Astronaut Duke was given intensive photography training prior to the mission. He was taught about f-stops, exposure, and learned how to operate a custom Hasselblad camera. He took thousands of practice pictures and hundreds on the moon. But he never considered himself much of a photographer. "Just a point-and-shoot man," he said decades later.

In the final hour of the final day of his three-day visit to the moon, Duke took out the shrink-wrapped family snapshot and gingerly placed it on the lunar surface, near the crater Descartes. It was his gift, his message to whoever might one day stumble upon it. He then took a snapshot of the snapshot. Evidence. A memory.

APRIL 23, 1972—THE MOON
This is the family of Astronaut Duke from Planet Earth. Landed on the Moon, April 1972.

Credits

Nicholas Osborn: 2, 18, 19, 25, 26, 27, 35, 51, 52, 53, 55, 56, 57, 71, 73, 74, 75, 76, 77, 79, 81, 82, 82, 86, 87, 88, 93, 94, 95, 99, 104, 105, 106, 107, 109, 112, 113, 114, 116, 117, 118, 119, 123, 125, 126, 127, 129, 131, 132, 133, 134, 135, 136, 138, 141, 142, 146, 147, 148, 149, 152, 153, 154, 155, 159, 164, 167, 171, 172, 173, 174, 175, 177, 178, 182, 183, 186, 187, 188, 193, 196, 197, 198, 200, 201, 202, 203, 205, 206, 207, 209, 210, 211, 212, 213, 214, 215, 216, 219, 220, 221, 231, 233, 234, 235, 236, 237

Stanley Fader: 6

Michael Williams: 8, 9, 10, 22, 23, 29, 30, 33, 34, 38, 39, 40, 43, 44, 45, 50, 54, 60, 62, 63, 65, 66, 69, 78, 82, 83, 85, 91, 98, 103, 108, 110, 115, 117, 120, 121, 122, 124, 126, 130, 137, 139, 140, 143, 145, 146, 147, 151, 158, 160, 161, 162, 165, 166, 176, 181, 194, 195, 208

Charlie Blaum: 11

Keith Ward: 14

Keith Sadler: 17, 20, 21, 22, 23, 24, 31, 32, 47, 48, 49, 64, 67, 70, 102, 169

Joyce Morishita and Bert Phillips: 36, 37, 38, 41, 46, 59, 61, 68, 90, 96, 97, 100, 101

Wisconsin Historical Society: 89

Thomas Stevick: 111, 179, 199

Louise Parsons: 115

Richard Cahan: 128, 141, 156, 157, 168

Holli Mintzer: 129

Frank Sugano: 163

Ruben Q. Gomez: 184, 185

Richard Clark: 189

Merritt Ernest Brown II: 190

Julie Jackson: 191

Adam Laiacano: 217

Charles Rathbone: 222, 223

Suzi Bonds Duke: 224

K. C. Winstead: 225

Ralph Vizzari: 226, 227

James and Linda Breslin: 228, 229

Mark Jackson: 230

National Aeronautics and Space Administration: 239